THE BEST OF
LENSCULTURE
VOL. 2

MW01038351

"It's a generous medium, photography."

Lee Friedlander

THE
BEST
OF
LENSCULTURE
VOL. 2

Schilt Publishing lensculture

INSPIRATION!

Photography is the most universal language on the planet today—it allows people from widely different cultures to communicate with each other immediately, in meaningful, powerful, and influential ways. Photography is so popular now that billions of photos (yes, billions!) are shared every day via the internet, social media, and smartphone apps. Millions more vie for our attention on TV, and in newspapers, magazines, and advertising. It seems we're awash in an endless flood of images.

The challenge, of course, is to discover the best and most interesting photography today and separate it from the rest. That is what this book proposes to do. With input from more than 30 influential experts in the international photo community, we've selected 162 photographers who are making remarkable work right now—and we think you should know about them.

These photographers—all winners or finalists of our international photography awards—have stood out from the crowd by producing work that is charged with uniquely personal points of view, masterful techniques, intriguing subject matter, compelling storytelling abilities, and fluency in the infinitely malleable language of photography.

With time and careful reading, great photos often reveal complex layers of meaning, nuance and interconnections that may not be apparent at first glance. These images seem to get better the longer you look at them.

A tremendous amount of information can be packed into a single photograph. American photographer Lee Friedlander made this observation about one of his own photographs:

"I only wanted Uncle Vern standing by his new car (a Hudson) on a clear day. I got him and the car. I also got a bit of Aunt Mary's laundry and Beau Jack, the dog, peeing on a fence, and a row of potted tuberous begonias on the porch and seventy-eight trees and a million pebbles in the driveway and more. It's a generous medium, photography."

Likewise, the rhythms and repetitions that a photographer creates in a series of photos can develop "ways of seeing"—encouraging the viewer to seek out and notice certain kinds of details or events. With energized eyes, we can scan a photograph and penetrate beneath its surface and travel outside the limits of the frame. Readers with engaged minds can look at the stillness of a photograph and bring it to life again—imagining before and after, above and below and behind, savoring the qualities of light and shadows, volume and shape, implications and suggestions. Photography becomes something to savor, to taste fully, to unpack.

So, we encourage you to take your time with the photographs and stories presented here. This book is designed as a resource for inspiration, a reference guide, and a point of departure—it is just the starting point of some amazing journeys. Most of these stories run deep, and you can experience every one in full by following the links to each photographer's website. All of these stories appear online in LensCulture, too.

Searching the world for the best

Since 2004, LensCulture has sought to discover the most interesting photographers working worldwide. Our editorial team scours the globe—attending festivals, portfolio reviews, exhibitions and graduation shows—in search of new and developing talents. And each year, we host four to six annual photography awards (published in 14 major languages) to extend our reach even further.

Using the power of the internet, social media, and tapping into photography networks worldwide, we are committed to finding and rewarding the most deserving photographers, no matter where they are. And we want to share our discoveries with photography lovers everywhere.

We are also deeply committed to education: Every photographer who sends in a body of work to our awards is eligible to receive written, critical feedback. By connecting photographers with professionals, we aim to help everyone who participates in our awards—not only the top winners.

The work in this book represents the best of four international awards. The LensCulture Exposure Awards, our longest-running awards, are dedicated to discovering the freshest and most exciting photography work being created today, without limitations of genre, style or subject matter—these awards highlight the many ways the visual language of photography can be used to tell compelling stories, express emotions, explain complex situations, reveal injustices, share the wonders of nature or celebrate beauty.

The Portrait Awards seek to explore the possibilities of 21st century portraiture. In this age of endless selfies and oversharing of mundane moments, what gives a portrait authenticity?

The Street Photography Awards look for new approaches to capturing the drama, interactions and juxtapositions that occur on the world's busy streets today, from the dense urban culture and clashing fashions of megacities to daily life in remote towns and villages.

And finally, the Emerging Talent Awards celebrate exceptional photographers who are not yet known on the world stage. They are selected for their abilities to use photography in profound ways. These awards are granted without regard to the age of the photographers or how long they've been practicing photography—they have earned their time to shine.

One of this year's expert jurors, Fiona Rogers of Magnum Photos, made this succinct comment:

"These awards succeeded in bringing together a diverse range of photographers— a rare chance to discover such an inspiring array of photographic approaches all in one place."

In this book, you will find work spanning 38 countries and five continents—a truly global snapshot of photography as it is being practiced today. We urge you to take your time while appreciating all of these photographers' work. Dig deeper into the projects that interest you and soak in the abundance that this wonderful medium has to offer.

Enjoy!

Jim Casper, Editor-in-Chief

EMERGING TALENT AWARDS

"This is why I'm so interested in emerging talents: They tend to look at the world differently than what we've seen before."

Arianna Rinaldo, Artistic Director, Cortona On The Move

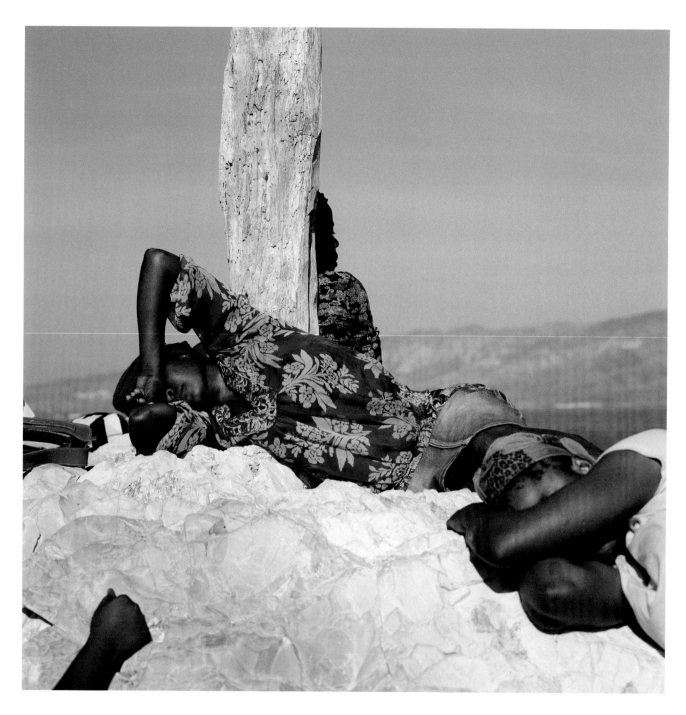

A group of the faithful in reverence at the summit of Ti Pinsik in Gonaïves, Haiti. These women gather around a wooden pole that once supported a large Christian cross.

THOMAS FRETEUR
HAITI

thomasfreteur.com

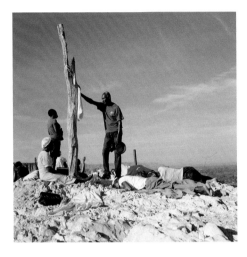

Through the looping repetition of certain verses, almost like mantras, the connection with God seems to grow even more sincere and sometimes transcendental.

In Haiti, people often say about the religious cults (in an ironic way and in a whisper), "60% are Catholics, 40% Protestants but 100% are Voodoo…"

THE FAITHFUL

On a road to the northern part of Haiti, not far from the city of Gonaïves, is a small hill called Ti Pinsik. It stands in an arid and rocky landscape. Only cacti, lizards and goats can survive in this environment.

On a day of thunder, about 40 years ago, a pastor was born at the foot of this hill. The news spread quickly: "A king is born." Since then, every morning (except church days), clusters of believers have flocked to the hill, gathering at Ti Pinsik to pray to their various gods.

As far back as the collective memory reaches, it has always been so. The faithful come and go from Ti Pinsik to sing, pray, dance, and sleep.

Resilience is a term frequently used by both NGOs and intellectuals to characterize the Haitian people.

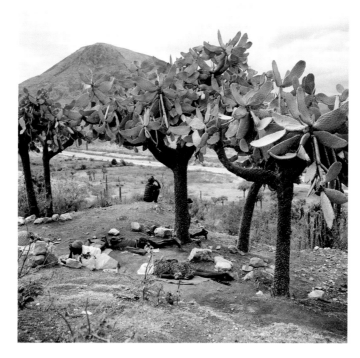

Whether in a group or individually, with a Bible or a smartphone, each believer tries to get closer to God.

At the top of the peak, a woman prays intensely. The red tarpaulin, rolled at her feet, will be spread onto the ground so that the faithful can prostrate themselves in the name of their gods.

Wind.

DAREN YOU
UNITED STATES

darenyouphoto.com

Ravens.

CHAOS

In this series, I explore how to reach the image beyond the edge of the photograph...how to let these images create themselves and avoid manipulation.

To achieve this, I use several techniques (both historical and contemporary) to process each image: reticulated film through a high temperature developing process, liquid emulsion, inkjet printing, darkroom printing and encaustic painting. By layering these processes together, on top of the same images, it becomes impossible to control the result.

Ferry.

A Rainy Night.

The coastal town of Progreso, where Korean immigrants first arrived on the Yucatán Peninsula, Mexico, in 1905. Progreso, Mexico, 2016.

MICHAEL VINCE KIM
ARGENTINA / SOUTH KOREA

michaelvincekim.com

Sandra at her home in Matanzas, one of the
cities with the highest number of Korean
descendants in Cuba. Matanzas, Cuba, 2016.

Swimming lessons on the beach at Matanzas,
Cuba, 2016.

AENIKKAENG

In 1905, around 1,000 Koreans arrived in Mexico aboard
the SS Ilford. They had departed an impoverished country
and were promised future prosperity in a paradisiac land.
However, once they arrived in Yucatan, they were sold off
as indentured servants.

 Over a century later, working from stories told by the
descendants of these Korean workers now living across
Mexico and Cuba, this project provides a poetic account of
their memories.

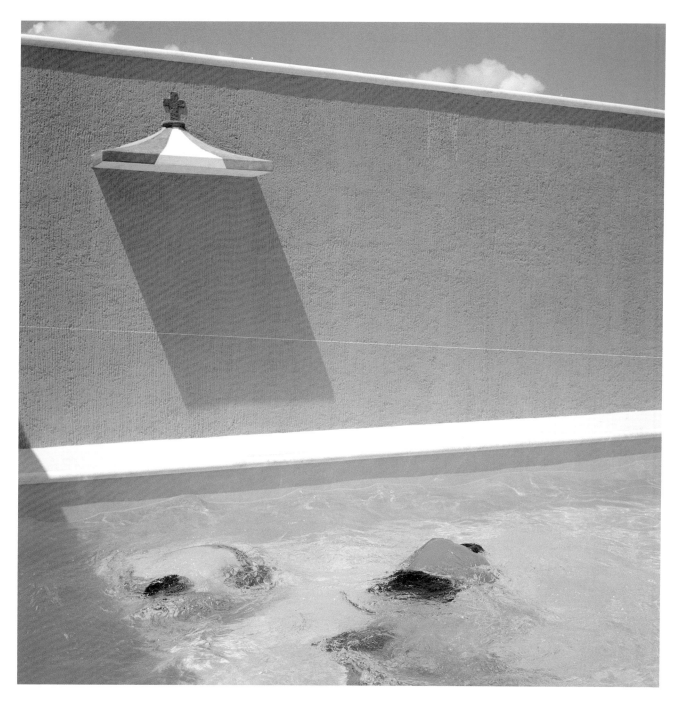

Young Korean-Mayans play around in the pool at the 90th birthday party of a second-generation relative. Merida, Mexico, 2016.

By the time the workers' contracts ended in 1910, Korea had already been incorporated into the Japanese Empire. With no homeland to return to, they decided to stay in Mexico. Today, their descendants are scattered across Mexico, Cuba, and beyond. Progreso, Mexico, 2016.

Pointy.

GIOVANNA PETROCCHI
UNITED KINGDOM

giovannapetrocchi.com

Esserino.

LANZAROTE

With this body of work, I intend to document my experience and visionary interpretation of the island of Lanzarote and its unique landscape. I encourage the viewer to reflect on how landscape is, or should be, understood today. By combining personal photographs of the island with hand-made collages, digitally-manipulated images and archival photography, I embark on an intimate investigation of the natural world.

Déjà vu.

Couple.

TURJOY CHOWDHURY
BANGLADESH

turjoychowdhury.com

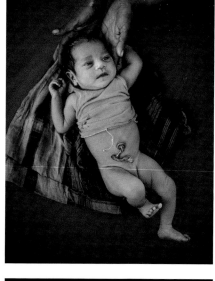
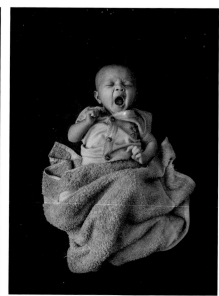
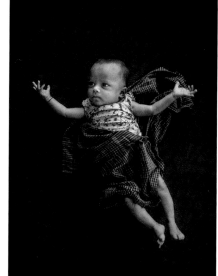
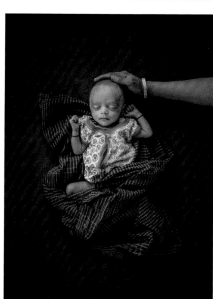

BORN REFUGEE

These portraits depict babies who were born refugees. They began their lives in the wombs of Rohingya women, crossed the Myanmar-Bangladesh border, and were brought into the world at refugee camps inside Bangladesh.

These babies are between one day and three months old. My approach was to show the babies not as refugees, but as innocent as any other newborn. My hope is to provoke questions about the future of babies born in an alien place, where they are given no rights and no statehood. Ultimately, I want to show that children are always the worst sufferers in any conflict, anywhere.

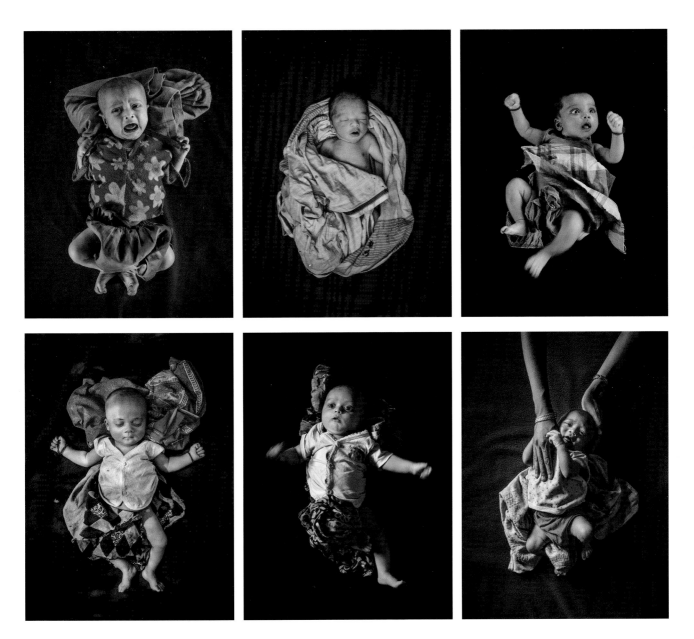

Nestled in colorful blankets given as aid, these babies are between a day and three months old.

Author's Hallucination No. 19—Lou.

jfredricmay.com

Author's Hallucination No. 83—Val.

Author's Hallucination No. 13—Verna.

APPARITION: POSTCARDS FROM EYE SEE YOU

This is a series of digital images created during my recovery from a stroke that left me legally blind in 2012.

The birth of these images began deep within my damaged brain as it began to make new neural connections. The results were startlingly vivid visual hallucinations.

Author's Hallucination No. 3—Les.

Author's Hallucination No. 59—Em.

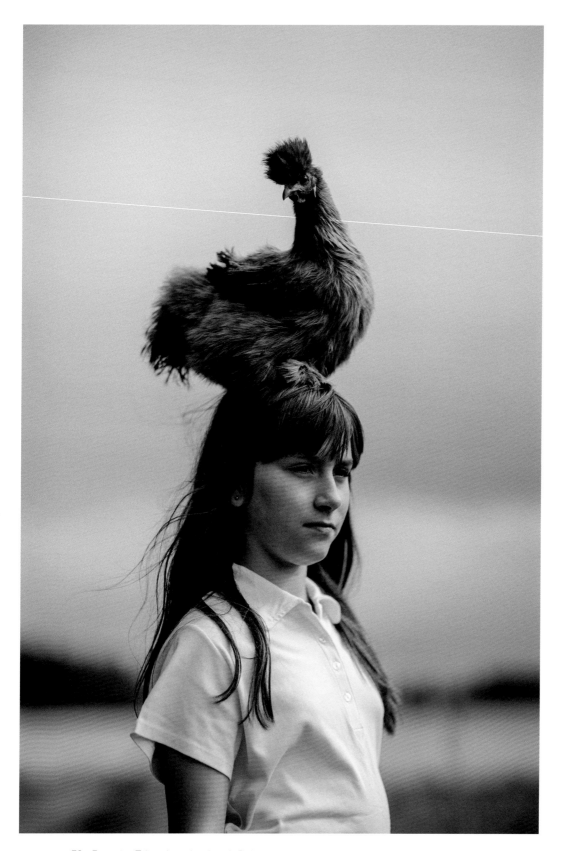

ALEKSI POUTANEN
FINLAND

aleksiphoto.com

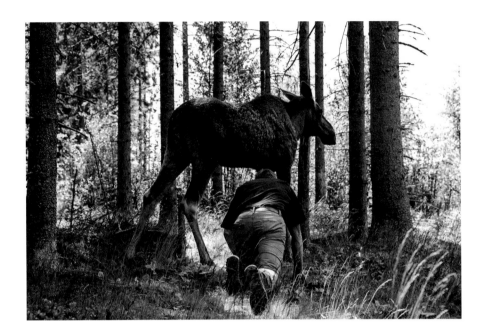

FELLOW CREATURES

Finnish people have a special relationship with nature—
animals in particular. During the 1960s, Finland experi-
enced exceptionally fast migration from its rural areas to
its cities. Before this change, people were used to sharing
their everyday lives with domesticated animals at home and
wild animals in the nearby forest. Despite the changes,
Finns have preserved a unique way of relating to their
animal friends.

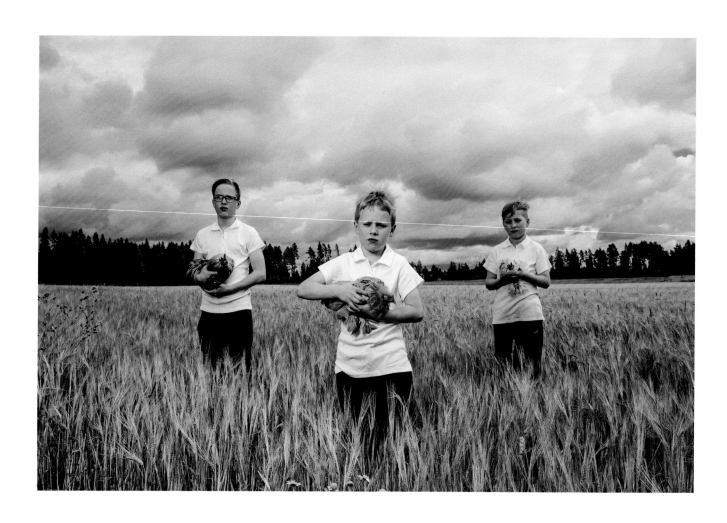

MATTHEW GENITEMPO
UNITED STATES

matthewgenitempo.com

JASPER

The men in these photographs have chosen to live a
sequestered life in the Ozark Mountains of Arkansas.
The project explores my fascination with running away
from the everyday.

100 HECTARES OF UNDERSTANDING:

This project is my attempt to understand a 100 hectare area of forest that I own. It includes both tangible and intangible approaches and visualizations of what forest and forestry mean to me and how the unknown becomes familiar. I study what nature has to offer to urbanized people and try to create new ways of thinking as well as ways to experience and feel the forest.

JAAKKO KAHILANIEMI
FINLAND

jaakkokahilaniemi.com

FLORENCE IFF
SWITZERLAND

florence-iff.ch

67P: This project is an investigation of light, time, and space as explored through photography, using the NASA space mission Rosetta as its starting point. Drawing on both old negatives and high-tech images of Mars, I create a visual journey that considers universal questions of our existence and the imprints we leave behind as human beings.

TRACE: My aim here is to uncover different traces of memory: those expressing emotions, places, or people. The process finds its beginning in daily life, by hearing, seeing, reading, or experiencing the things that draw my attention.
I like to think of my images as poems made from a deeply personal point of view in order to understand universal feelings.

ANNI HAŃEN
FINLAND

annihanen.com

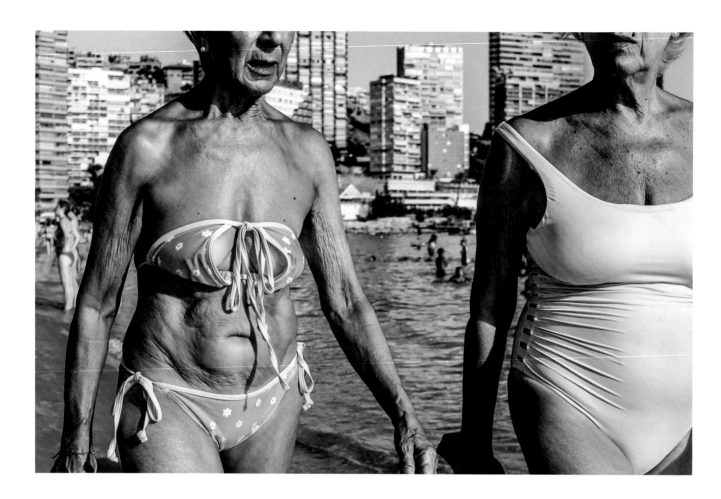

CANDY BEACH: The beach at Benidorm, Spain, is beautiful—giant, full of color and packed with fantastic characters. It is also full of lovely imperfections. This is the purpose of my work: to show the city as I see it, as I feel it. Filled with light and color, life and beauty.

BAMBI NO MUERE
SPAIN

bambinomuere.com

ALEXEY SHLYK
BELGIUM

alexeyshlyk.com

THE APPLESEED NECKLACE: It remains quite normal in Belarus to have students harvest potatoes. It's almost an obligatory summer job. My classmate came unprepared for such dusty work, and the crafty tractor driver made him protective glasses out of the available materials—a plastic bottle and a rubber string. This ability to make something vital out of nothing really surprised me.

MAKESHIFT: The landscape in Bosnia and Herzegovina bears the marks of the Bosnian War that a newly-written history is attempting to erase. The site in this photograph is an abandoned restaurant and motel complex in VogošĐa. The motel housed women, while an attached bunker housed men. According to one source, the motel held 50 to 60 Bosnian Muslim girls. The commanders were allowed to rape the detainees.

PAWEŁ STARZEC
POLAND

pawelstarzec.com

FABIEN FOURCAUD
FRANCE

fabienfourcaud.com

SANCTUARIES: Zoos and natural history museums all over the world sanctify a very specific idea of nature, choosing artificial landscapes over storytelling. These simulacra, instead of preserving the idea of "nature," end up shaking it by redefining our relationship to the landscape that surrounds us. My work proposes a new model that accepts contemporary nature's necessary artificiality.

E-COMMERCED ANIMALS: With just one click on Amazon.com, dead animals can be delivered to our houses—for us to eat them, wear them, or feed them to our pets. Is this extreme capitalism? A symbol of our convenient lifestyle? Or needless animal slaughter? All the animals I photographed were purchased, legally, online.

TOMOFUMI NAKANO
JAPAN

tomofuminakano.com

ITTOQQORTOORMIIT: Remote and far from the hustle and bustle of modern life, lying well above the Arctic Circle in northeast Greenland, I photographed one of the most isolated places in the Northern Hemisphere— a small settlement called Ittoqqortoormiit.

MICHAEL NOVOTNY
CZECH REPUBLIC

michael-novotny.com

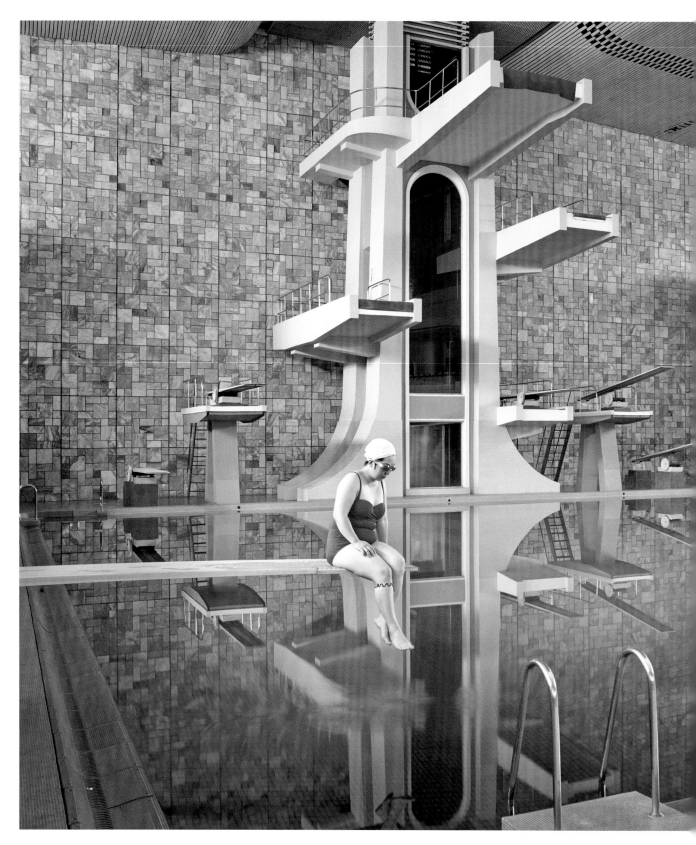

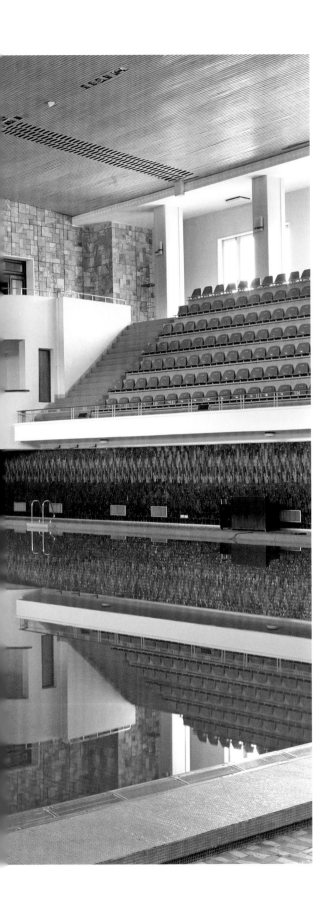

SETTING THE STAGE | NORTH KOREA:

The government of North Korea has rebuilt its capital, Pyongyang, as the ultimate socialist city and the perfect setting for state propaganda. The buildings were designed to provide the inhabitants with a utopian background for their everyday routines—though many places, such as this swimming complex, are primarily shown as part of official tours for foreign guests.

EDDO HARTMANN
THE NETHERLANDS

eddohartmann.nl

MY TOWN, SIÓFOK II: This is my birthplace precisely as it exists in my mind: the small Hungarian town where I grew up, Siófok. Perched on the shore of Balaton, the largest lake in Central Europe, the place has long been a magnet for tourists. But while most know it only as a place for vacation, as a local I am able to show this place in an unusual and unexpected context.

MARIETTA VARGA
HUNGARY

behance.net/mariettavarga

BOYUAN ZHANG
CHINA

zhangboyuan.me

A GRAVEYARD OF CANDY: Korla, Xinjiang. I was born in Xinjiang, a vast territory located in the northwest of China. Long seen as a frontier, the place is home to dozens of different ethnic groups. Though I was born and raised here, I am also a descendant of Han "immigrants." But I want to make this place my homeland: I believe I can engrave these scenes on film as well as in my heart.

AUSCHWITZ: ULTIMA RATIO OF THE MODERN AGE:

The defining logic of the architecture in the Auschwitz concentration camp was that the forms of the buildings were absolutely subordinated to their function as instruments of industrial genocide—a chilling case of "form follows function." My typological examination of the camp's buildings and objects aims to enable the spectator to compare the different methods of rationalization employed by the architects of this site of mass killing.

TOMASZ LEWANDOWSKI
GERMANY

tomaszlewandowski.de

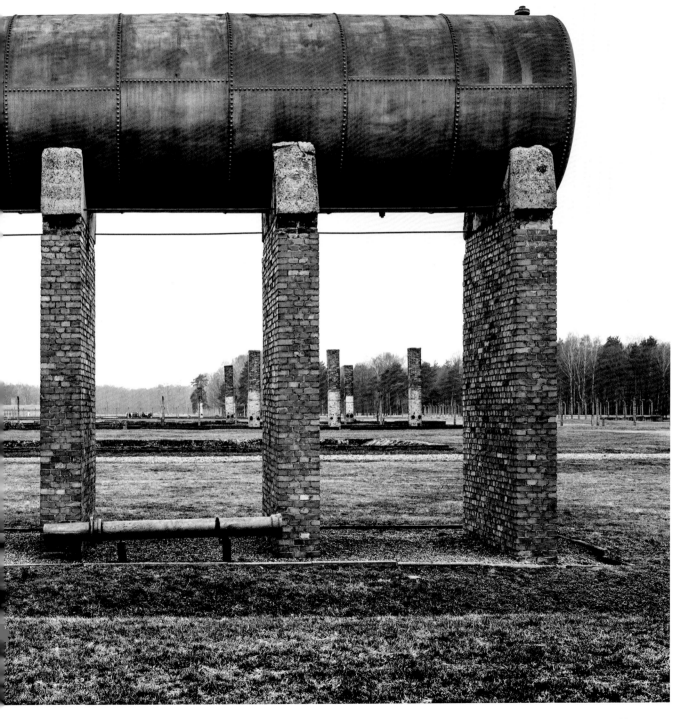

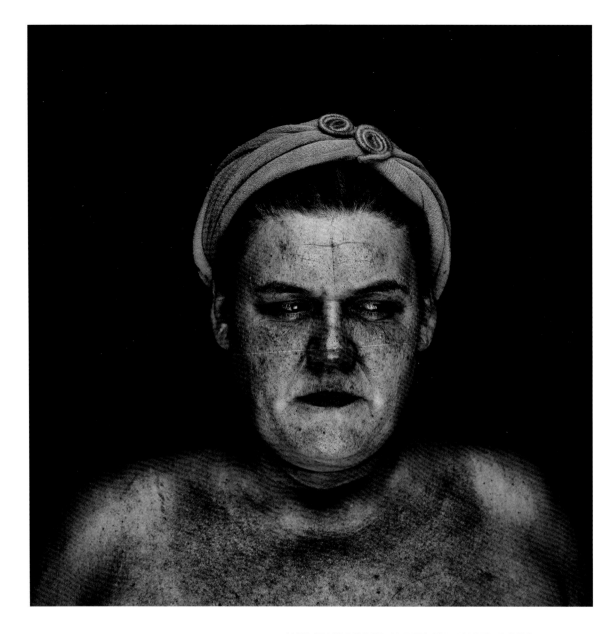

I HAVE MORE MEMORIES THAN IF I WERE A THOUSAND YEARS OLD: Baudelaire first expressed that idea in a poem. We all have unmentionable, unspeakable thoughts that we fear. We all have worries and anxieties we want to hide from the people around us. I have tried to bring these fears to light. I have tried to highlight and collect them. I want to make decipherable the invisible thoughts and worries we have tattooed on our body, but that nobody ever sees.

PIETRO BARONI
ITALY

pietrobaroni.com

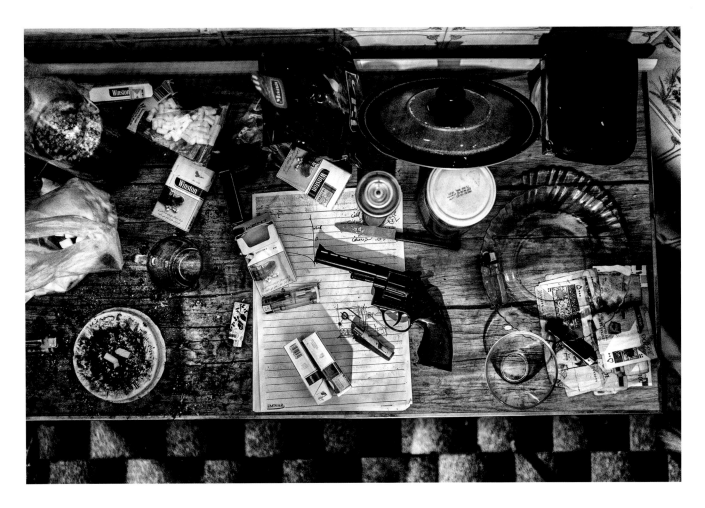

FROM LABYRINTH: The kitchen of a fourth-year architecture student. Being young in Iran means limitations felt in politics, art, culture, entertainment, economy, education, clothing, speech, behavior, femininity, masculinity, relationships, and life. As my friends often say, "We are the generation after revolution and after war." I am searching for evidence of the growing complexity, anxiety, and fears faced by those of my generation.

FARSHID TIGHEHSAZ
IRAN

farshidtighehsaz.com

EVERY BODY HAS A STORY TO TELL: Body image is something I've struggled with, even as a male. The mainstream media feeds us images that are unattainable for a lot of us. This project is simply a celebration of women's bodies; each of them tells a story.

RA TINOKO
UNITED KINGDOM

ratinoko.com

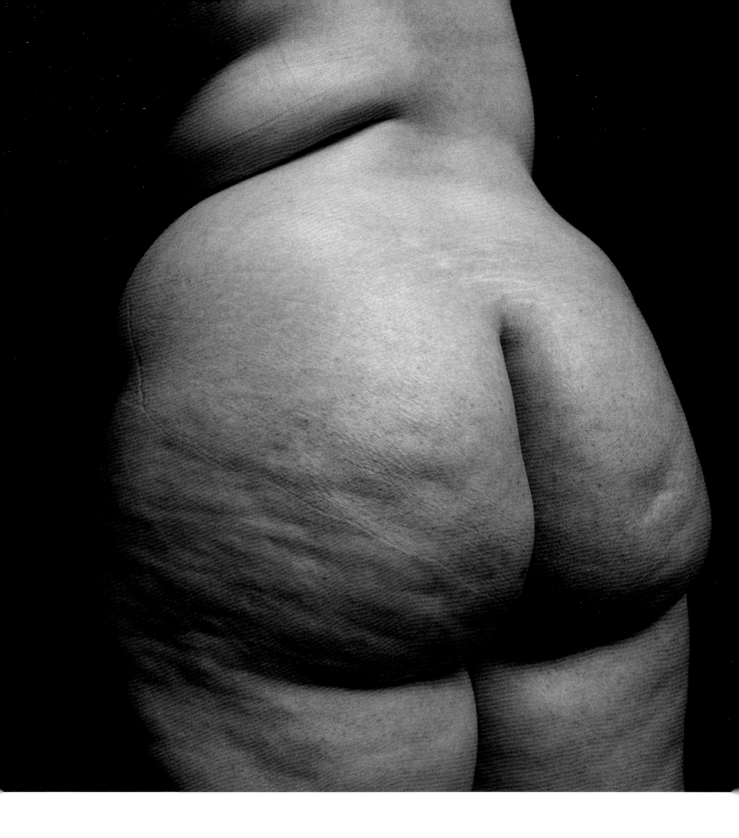

CHILDREN OF ZANSKAR: Documenting the lives of the youngest inhabitants of Lingshed, one of the most isolated settlements in the world. Perched at 13,000 feet above the sea, and nestled within a vast cauldron of mountains deep in the Indian Himalayas, Lingshed offers a view not easily forgotten.

JAREK KOTOMSKI
UNITED KINGDOM

kotomski.com

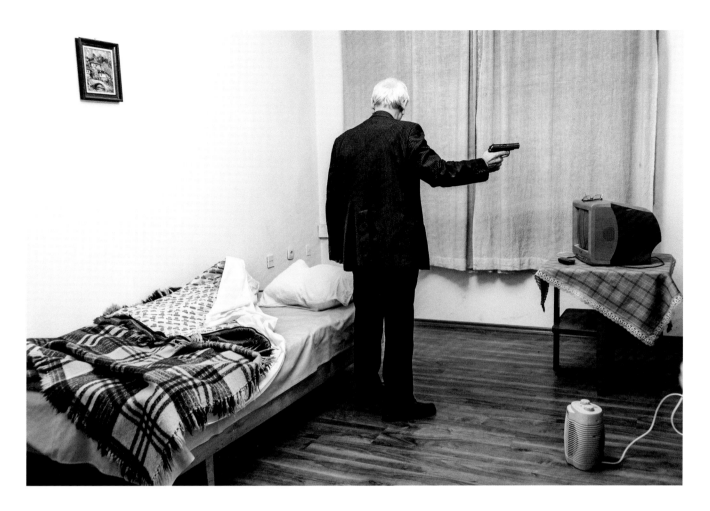

T(H)RACES: In January 2007, Bulgaria joined the European Union. It was a dream come true. However, 45 years of communism had a lasting effect: the past is omnipresent, and it seems there is no future ahead. The future had to be reinvented while taking into account many uncertainties and absurdities. Time seems to stand still today. Nostalgia for the past rushes into this new void, and desires are surreal. What remains of Bulgaria today?

VLADIMIR VASILEV
FRANCE

vladimirvas.wixsite.com/vasilev

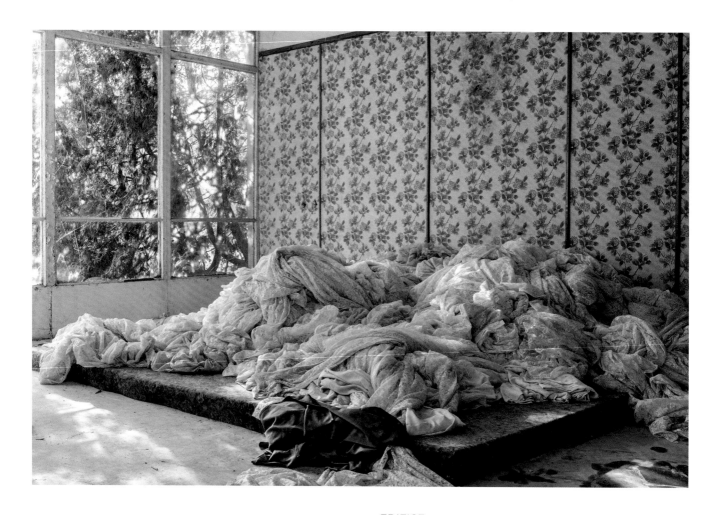

EDIFICE: A visual journey back to a time most people would like to forget; I document buildings that have survived the Communist regime in former Czechoslovakia. Here, the interior of the Polana Hotel, a closed holiday facility once owned by the country's Communist Party. A fine example of Socialist Realism, it was visited in its day by Nikita Khrushchev and Fidel Castro. My project tells a story about power and its impermanence.

KAROL PALKA
POLAND

karolpalka.com

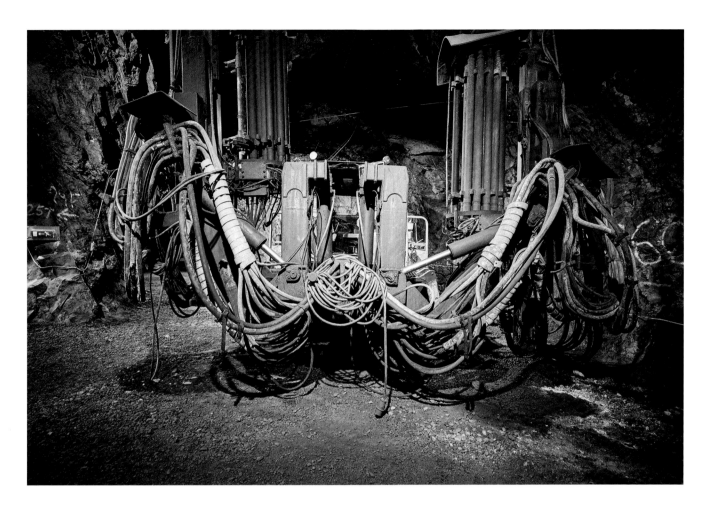

IRON HEART: The city of Kiruna is situated just north of the Arctic Circle. Underneath lies an iron ore body, supposedly the single largest in the world. Now, after more than a century of mining operations, the ground is disappearing from below. As a result, the entire city center will be moved and rebuilt three kilometers away on a more stable site. This series examines the para-doxical relationship between the mine and the city: the city only exists because of the mine, but it is now forced to start a new existence due to the mine's function.

GREGOR KALLINA
AUSTRIA

gregorkallina.com

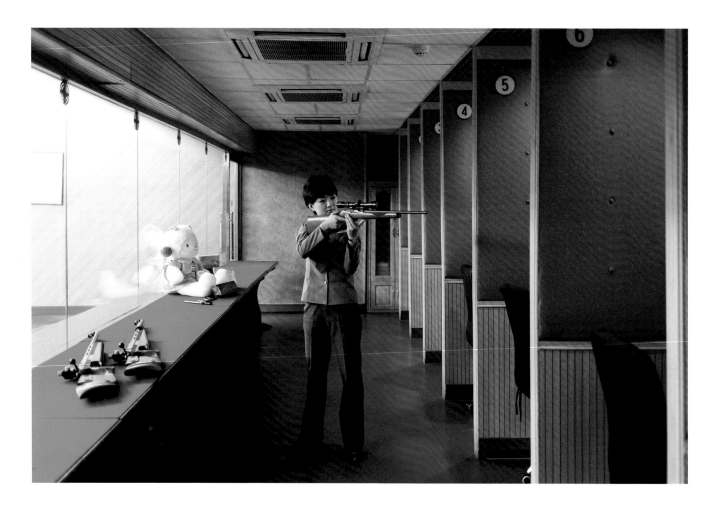

KOREAN DREAM: Kim Hyang, 22 years old, works at the Meari Shooting Range in Pyongyang. North Korea is a totalitarian dictatorship and one of the most secluded countries in the world. Its citizens' rights are subsumed by the country's needs. Within the country, continuous and incessant propaganda against the US puts the residents in a constant state of alert, as if the US could attack on any day.

FILIPPO VENTURI
ITALY

filippoventuri.photography

HANAFUDA SHOUZOKU: When I was a child, my grandmother said, "Anything with a shape will eventually be gone." What she told me has remained in my mind to this day. The idea for this body of work came to me when I found rotten food inside a box that my mother had sent me from my hometown. I felt so sorry when I thought of my mother's affection towards me. I portrayed the rotten food like a dead or dying soul and dressed it up in "shouzoku," or "costumes," that would give it a fitting appearance for its journey into the next world.

SHINYA MASUDA
JAPAN

shinyamasuda.com

RANA YOUNG AND ZORA J MURFF
UNITED STATES

ranayoung.com / zora-murff.com

FADE LIKE A SIGH: Together, Zora J Murff and Rana Young began mining their family histories, exploring the void left by absent parents. Using their collections of personal photographs and reinterpreting them through their own contemporary imagery, they highlight the complicated relationship between photographic records and the fragmented and abstract nature of memory.

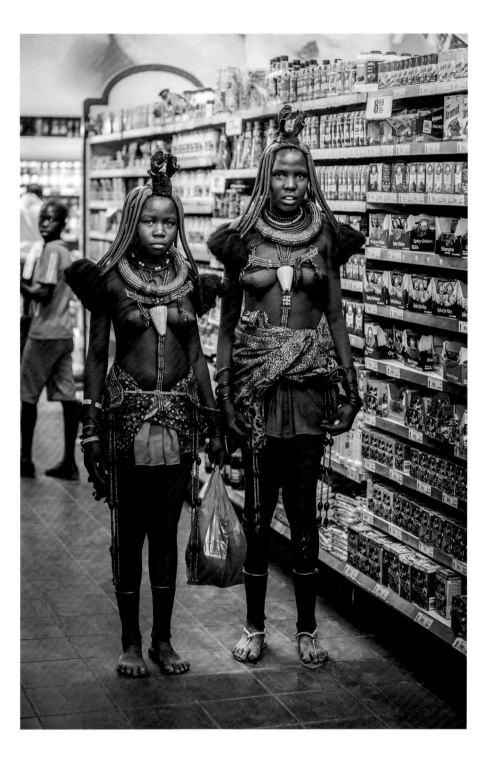

UP TO HERE AND NO FURTHER: Diversity of tradition is what I discovered in Opuwo, Namibia. Located in the northwest part of the country, it is the only settlement where petrol and limited supplies of groceries can be purchased for several kilometers around.
I found myself amidst a vibrant gathering of people who had come here from the remote corners of the surrounding countryside. Every person was elaborately dressed, representing their tribe or heritage. They all became examples of how diversity in culture can coexist in a very natural way.

JENNIFER BREUEL
GERMANY

jenniferbreuel.com

BLACK DOTS: Far from civilization and mostly accessible only by foot, bothies are secluded shelters scattered across the British Isles and tirelessly maintained by volunteers from the Mountain Bothies Association. Unlocked and free to use, they have become an iconic feature of the British landscape over the past 50 years and are synonymous with the outdoor experience in the UK. These photographs are my study of mountain bothies and bothy culture.

NICHOLAS JR WHITE
UNITED KINGDOM

nicholasjrwhite.co.uk

BACKLANDS (SERTÃO): Once an essential worker, 85% of the donkeys in the backlands of Brazil's countryside are now abandoned. This situation reveals not only a rural, economic transformation but also the end of an old culture related to the animal's relationship with the traditional people.

FELIPE FITTIPALDI
BRAZIL

felipefittipaldi.com

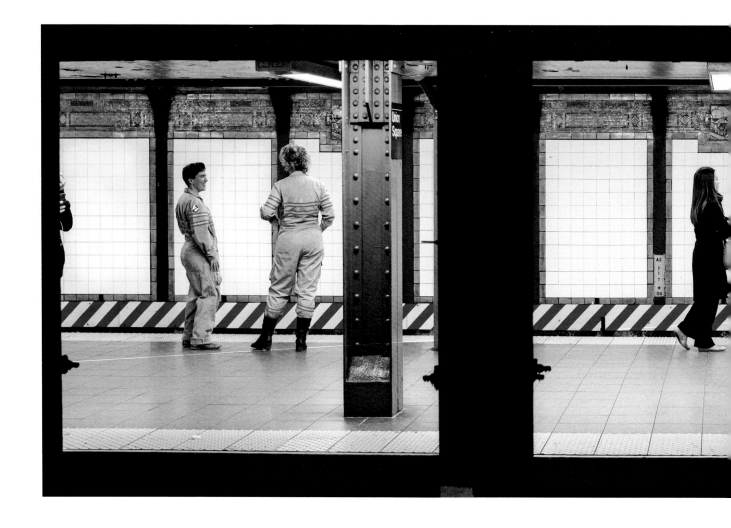

NATAN DVIR
UNITED STATES

natandvir.com

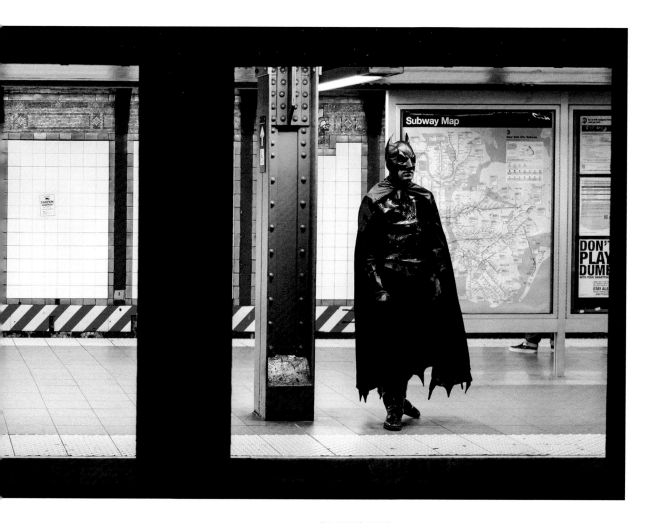

PLATFORMS: Thousands of people (and some strange characters) pass through the unique underground architecture of New York City every day. Visually reminiscent of photographic filmstrips, the ubiquitous subway columns organize the space into multiple narratives. Looking at the waiting commuters across the tracks offers a voyeuristic experience dramatically framed by the design of the space.

PUBLIC SPACES: We live in a world surrounded by advertising. Every day, we are presented with thousands of advertisements—but do we pay attention to them? We need to put our eyes back on the advertising that surrounds us so we can scrutinize our coexistence with its ubiquity, both individually and socially. To tackle the issue, I put into play an "anti-advertising" filter which eliminated the ads and left the billboards deprived of their original function.

JORGE PÉREZ HIGUERA
SPAIN

perezhiguera.com

MAIJA SAVOLAINEN
FINLAND

maijasavolainen.com

LIGHTWORKS: In my practice, I explore ways of using sunlight in a painterly way—as if light were a tangible material to the camera, like paint for a brush. These are images about the photographic gesture: observing, recording and storing light. My pictures are studies of feeling and composition.

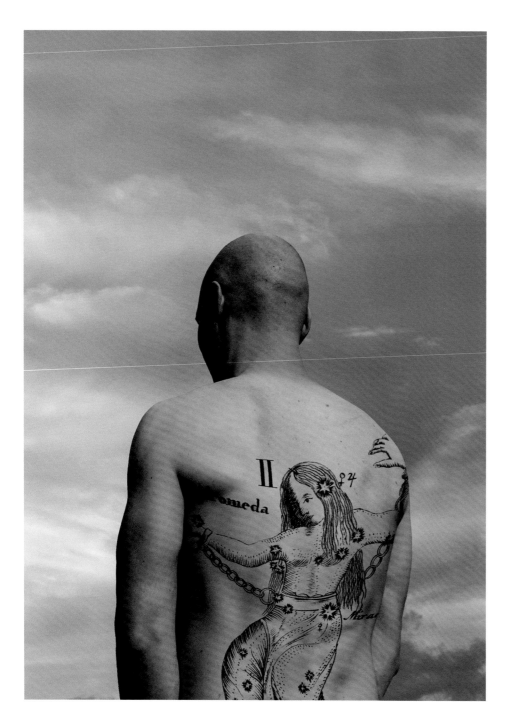

KAJNIKAJ—HERE AND THERE: I live in a small town in Silesia, and at some point there might have been something interesting going on here, but it was so long ago that it has since been buried in memory. If not for the dead mine shafts protruding from below, my town might be located anywhere. When I look at the sky over the decaying town, I am trying to find a means to escape from the place I was born and raised—even if it is a futile attempt.

KAJA RATA
POLAND

cargocollective.com/kajarata

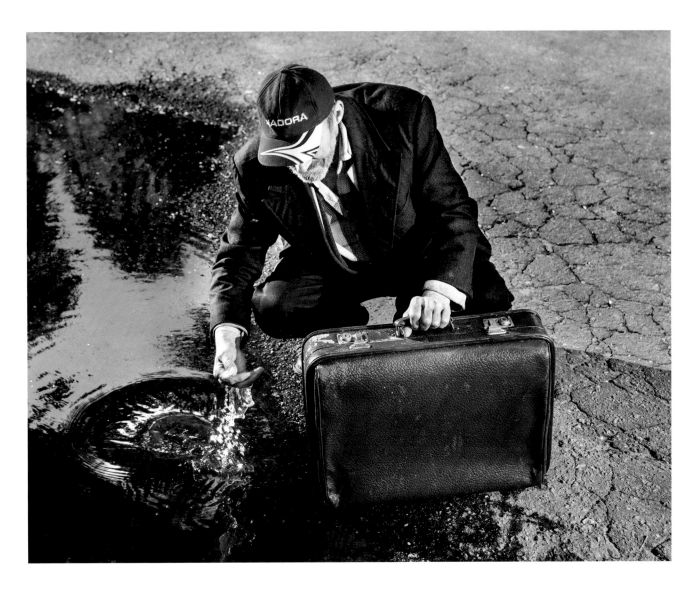

LET US NOT FALL ASLEEP WHILE WALKING:
An exploration of Ukraine over a period of 50 days.
My approach is collaborative, as I talked with the people
I photographed and integrated their perspectives into
the images I produced. Rather than providing definitive
answers, I use photography as a tool to explore the locals'
testimonies of life within the borders of their homeland.

DAVID DENIL
BELGIUM

daviddenil.com

ZUKUNFT (FUTURE): Birds cover a winter sky. My grandmother always said that the bombs of World War II sometimes looked like pearls falling down from the sky, blinking in the sun. When they fell on her family's house, she was alone, getting ready for bed. It was a miracle that she survived.

SARAH PABST
ARGENTINA

sarahpabst.com

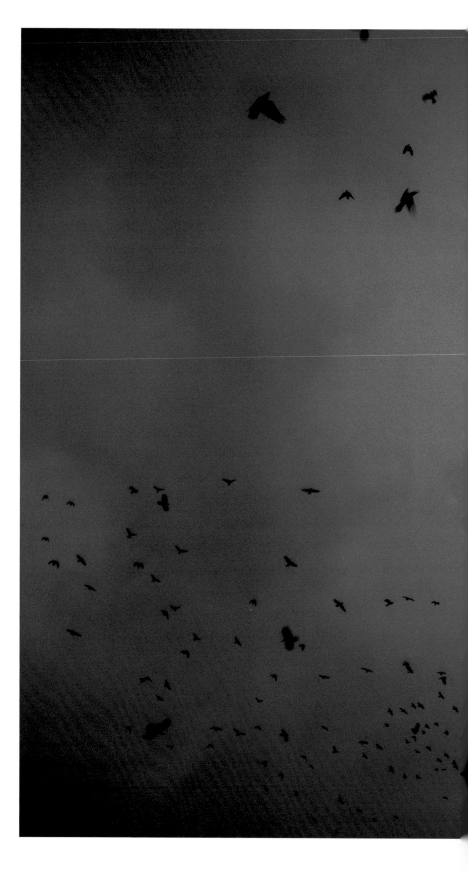

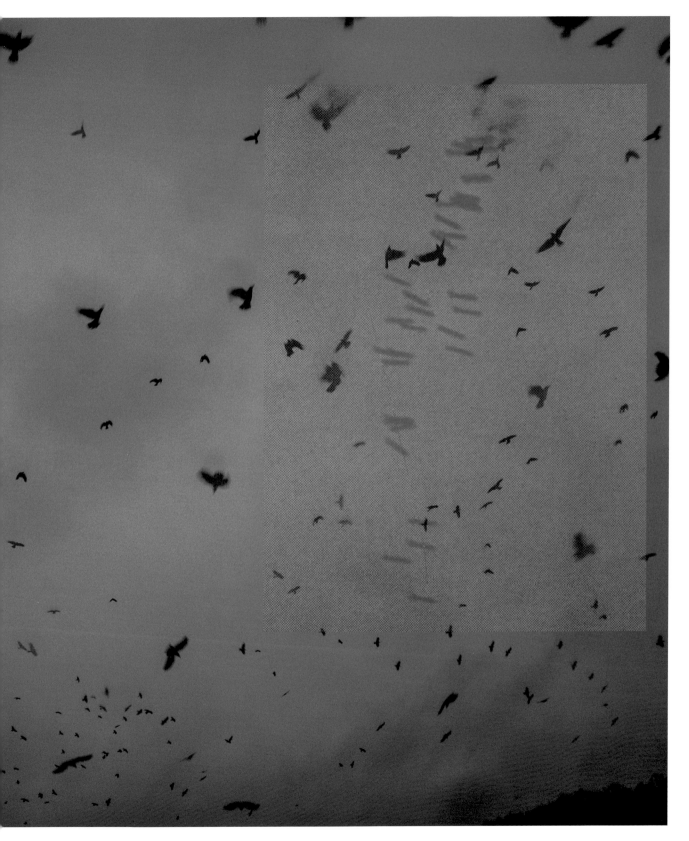

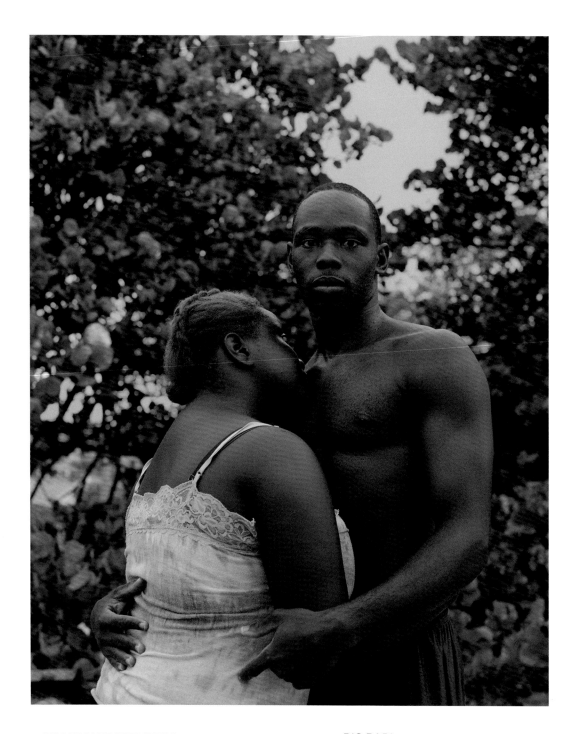

GILLEAM TRAPENBERG
THE NETHERLANDS

gilleamtrapenberg.com

BIG PAPI: Curaçao is an island of paradoxes where the cliché of macho culture exists alongside strong, independent women and pink-colored skies. This is my visual research project into the image culture of masculinity set against a sunset-lit landscape—a time of day when borders are less defined.

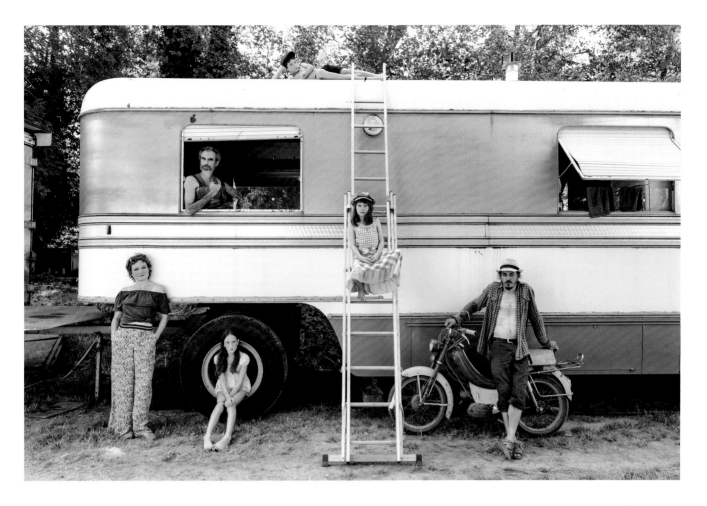

CIRCUS LOVE: THE FISHERMEN OF DREAMS:

"Les Pêcheurs de Rêves" is a small French circus
where Florence and Vincent play clowns Za and Krapotte.
Real life mixes with fiction in their show—the circus,
with its delight and its despair, is a metaphor for life.
This is the second chapter of a long-term project on
the contemporary, itinerant circus.

STEPHANIE GENGOTTI
ITALY

stephaniegengotti.com

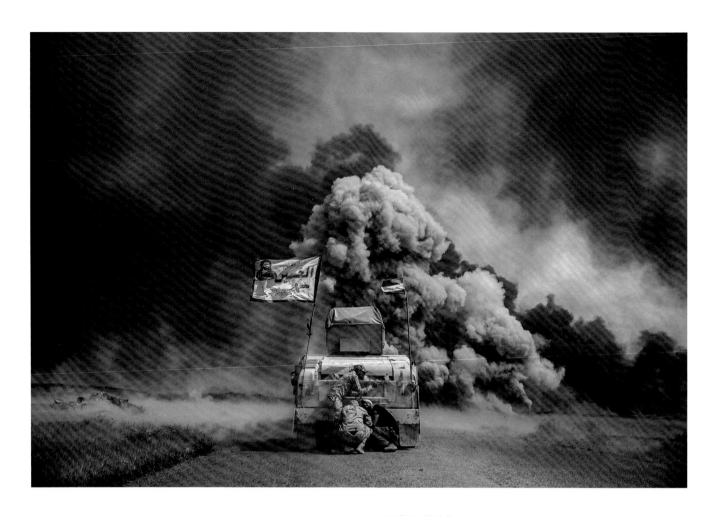

WAR IN IRAQ: In the summer of 2014, the Islamic State of Iraq and the Levant (ISIL) launched a military offensive in Northern Iraq and declared a worldwide Islamic caliphate, eliciting a military response from the United States and its allies. My photos of the war were taken in the cities of Fallujah, Mosul, and Al-Hawija in Iraq.

HOSSEIN VELAYATI
IRAN

hosseinvelayati.com

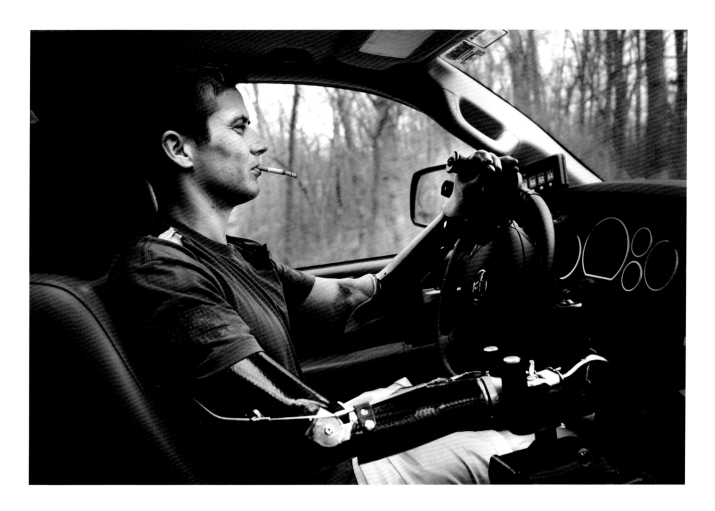

**THE ENDURING LIFE OF A QUAD AMPUTEE
VETERAN:** On March 26, 2010, US Marine Corps
corporal Todd Nicely was leading a patrol of 12 marines
in Afghanistan's Helmand province. He was 26 years
old. On this day, his life changed. Over a year and a half
after stepping on an improvised explosive device, Nicely
learned to walk again. He had to re-learn how to eat,
shave, and drive a car, all with the help of his new
prosthetic limbs.

FEDERICO BORELLA
ITALY

federicoborella.com

DARKROOMS: In Mulo, in the Democratic Republic of
the Congo, a mental health clinic hosts over 70 people
from across the North Kivu region. Many of them are
victims of post-traumatic stress disorder due to the
ongoing conflicts that have been stifling the area for
more than 20 years.

GIOVANNI SALVAGGIO
ITALY

giovannisalvaggio.it

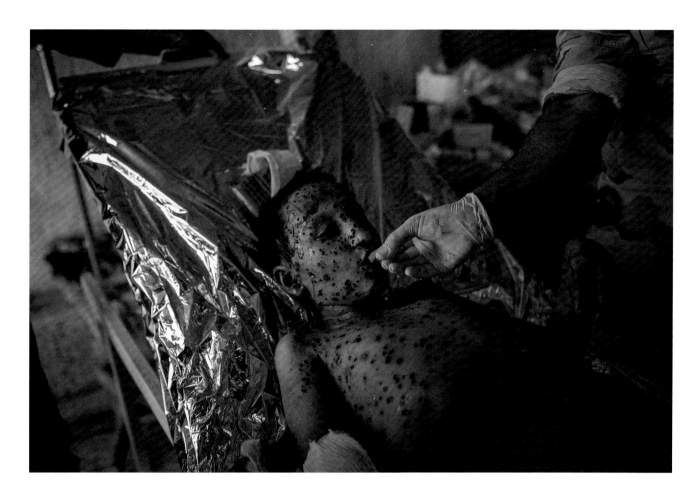

THE COLLAPSE OF A CALIPHATE: 14-year-old Mahmoud Abdulameer, injured by an IED, sips water out of a bottle cap while receiving treatment at an Iraqi army field base outside the Old City, West Mosul. A long-term project documenting the fall of the Islamic State in both Iraq and Syria; the images included in this series are from battles for al-Raqqah, Deir ez-Zor, and Mosul.

MATTHEW MCMAHON
NORWAY

matthewmooremcmahon.com

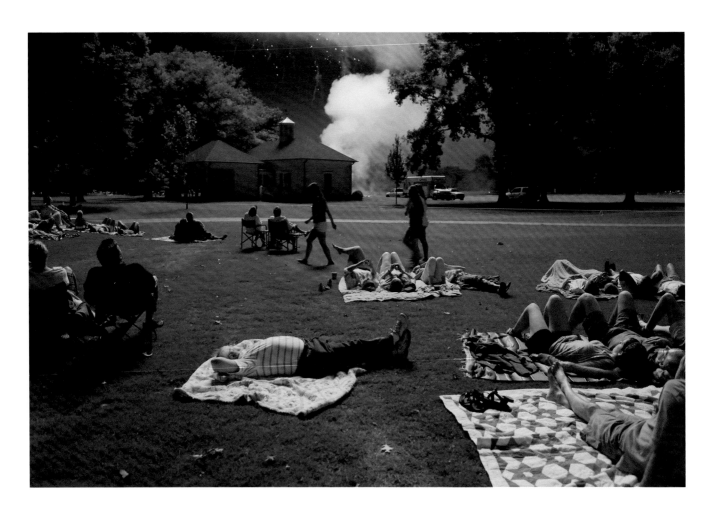

SHE'S NOT THERE: Photographs that evoke a vernacular modernity of planar surfaces, unexpected light, and industrial products in 21st-century America. These images have an eye for shape and form, as well as a sense of detail both as noun (the architect's craft of construction) and verb (the love and even fetishization of finish). Work that coaxes and spurs us to look again at the world in which we live.

PRICE HARRISON
UNITED STATES

priceharrison.net

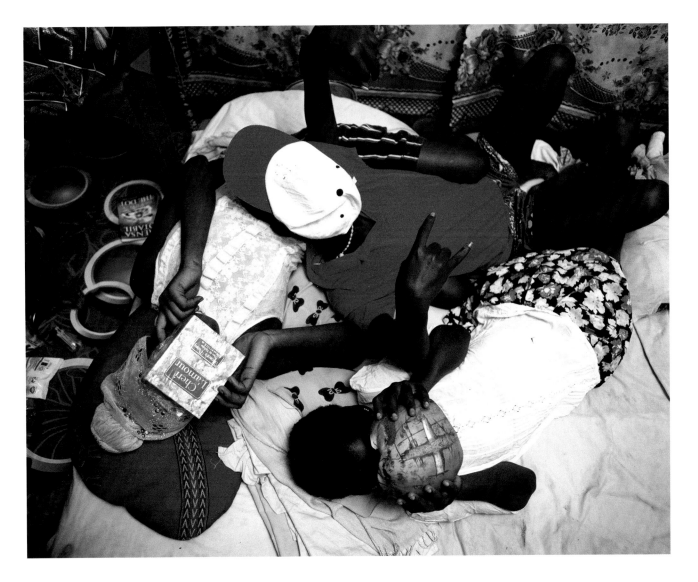

BUTTERFLIES ARE A SIGN OF A GOOD THING:
Three sisters—Abigirl, Ayse and Victoria—in Buduburam
Camp, Ghana, 2017. A series focusing on women and
their methods of survival in a place that offers few
economic opportunities for them. Rich imagery evokes
atmosphere and emotions rather than straightforwardly
documenting reality to tell their story.

ULLA DEVENTER
GERMANY

ulladeventer.com

VICTORIA J. DEAN
UNITED KINGDOM

victoriajdean.com

THE ILLUSION OF PURPOSE: Technology is restructuring our communication methods, transforming our perceptions and interactions with our environment, and rendering the physical realm comparatively cumbersome and slow. Yet the material structures photographed here, with the simplicity and directness of a symbolic form, withhold their messages, like relics of a forgotten language.

KIMMO METSÄRANTA
FINLAND

kimmometsaranta.com

NOTIONS OF THE CITY; NOTES ON A PLACE:
My work consists of observations and thoughts about
the city seen through the eyes of one protagonist—me.
I want to break my everyday patterns in order to question
and challenge my ways of seeing. My aim is to take hold
of my surroundings, to step out and truly see instead of
merely looking.

PORTRAIT
AWARDS

"Faces are the ledgers
of our experience."

Richard Avedon

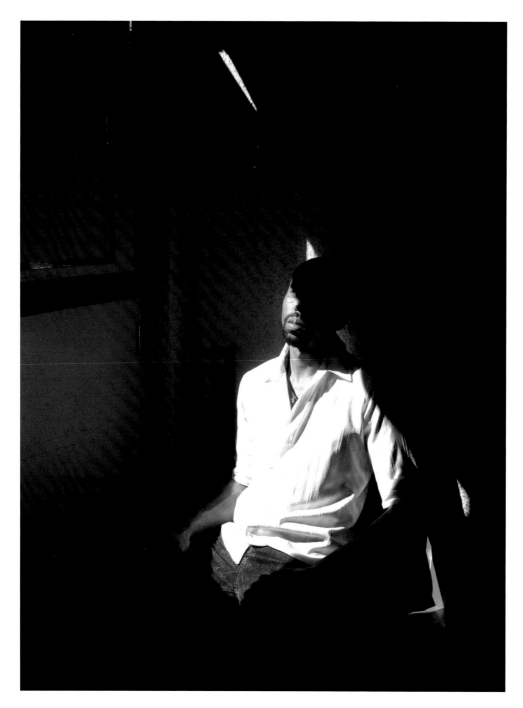

Silvio, 28. Security guard at a nightclub. Single. He visits a prostitute three times a week and pays $40 for 40 minutes with two girls. He started making use of these services when he was 14, out of curiosity. He likes to spend time with women when he's drunk.

CRISTINA DE MIDDEL
MEXICO

lademiddel.com

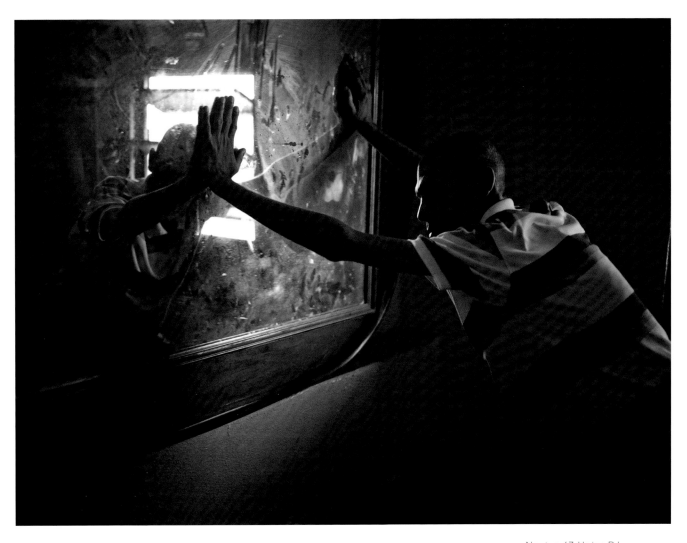

THE GENTLEMEN'S CLUB

Traditional photographic and media coverage of prostitution
has focused on only one half of the business. With this
series, I try to give visibility to the other 50%.

In June 2015, I put an advert in a newspaper in Rio de
Janeiro asking for prostitutes' clients to pose for me in
exchange for money. I asked the clients about their experi-
ences, personal history, and motivations. My intention was
first to see who these people were and also to invert the
roles of the business, as the clients would be selling part of
themselves. This is a selection of images featuring the men
who accepted the deal.

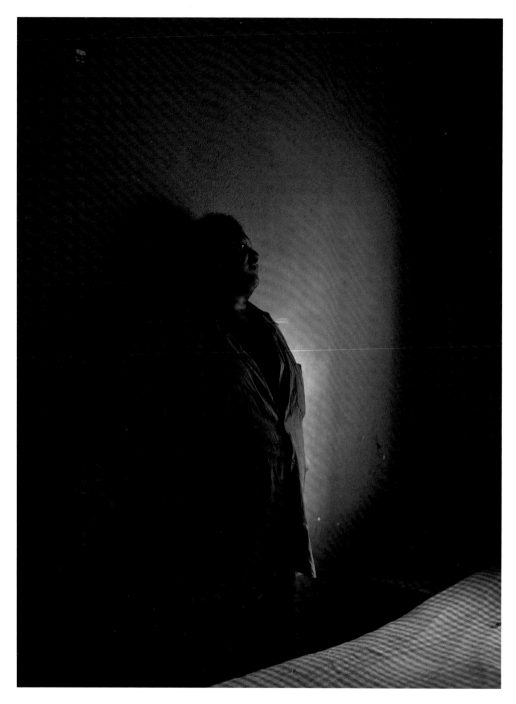

Luis, X. (he prefers not to say how old he is). He is an electrician who is single and father of two sons. He visits a prostitute once a week and pays $8 per session. He was 11 when he started using the services of prostitutes and he keeps doing so because he feels very lonely.

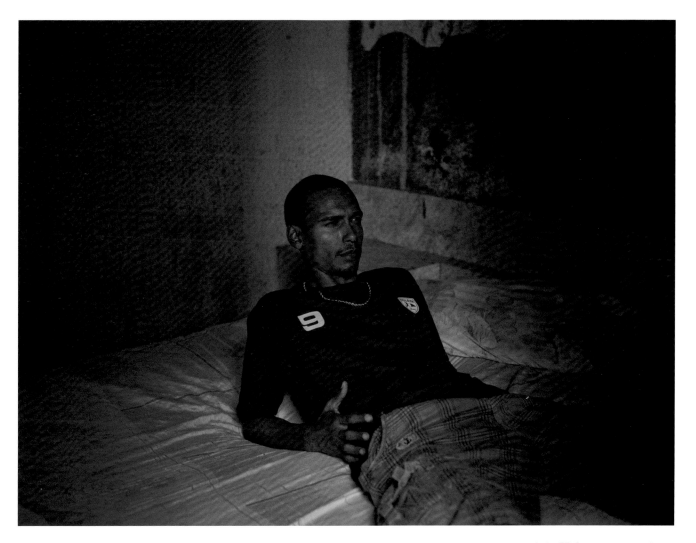

Italo, 35. Construction worker.
Married and father of six.
He visits a prostitute two or
three times a week and pays
$30 per session. He started
visiting prostitutes when he
was 18 years old and he keeps
doing it because he likes sex
with no strings attached.

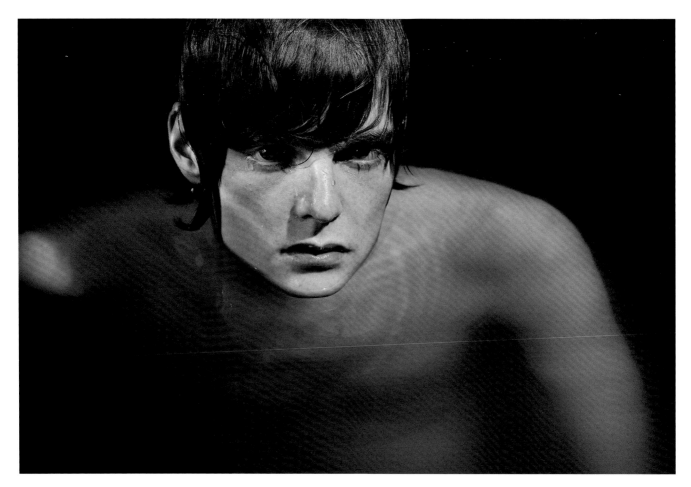

Antoine.

COCO AMARDEIL
FRANCE

cocoama.com

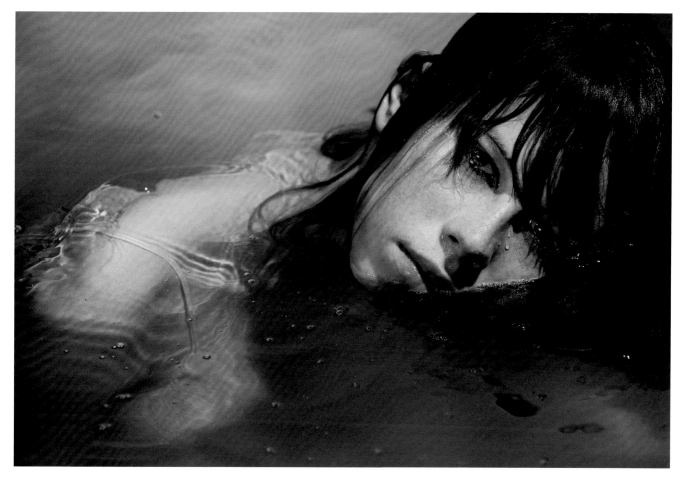

Camilla.

COME HELL OR
HIGH WATER

Today's youth live in a time where uncertainty about the
future—fueled by a distrust of politics, institutions, and the
media—has reached epic proportions. It is this moment in
life, a time of soul-searching and self-discovery, that I wanted
to capture through my series of portraits. This generation
will make up the world of tomorrow, without having much of
an idea of where they are going or what they want. They
are just trying to keep their heads above the sea of stimuli
that surrounds them.

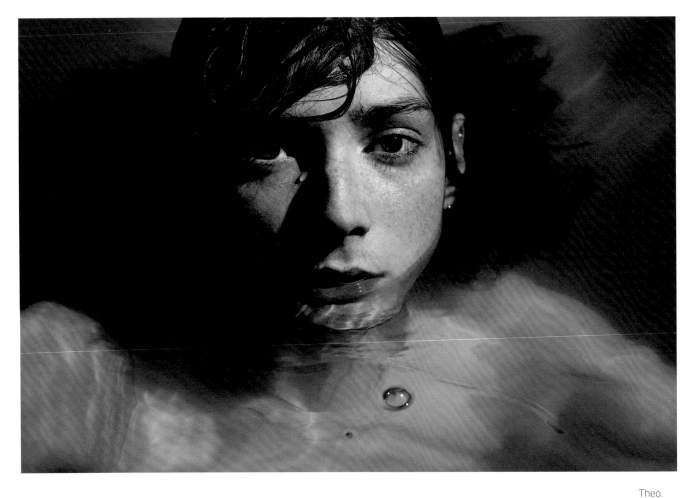

Theo.

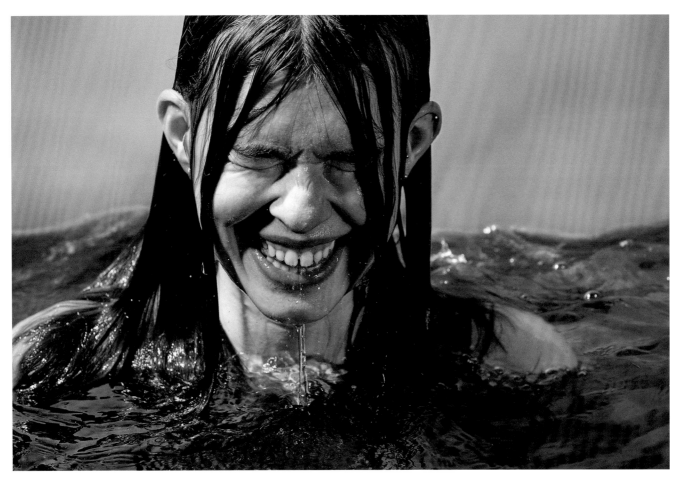

Stephania.

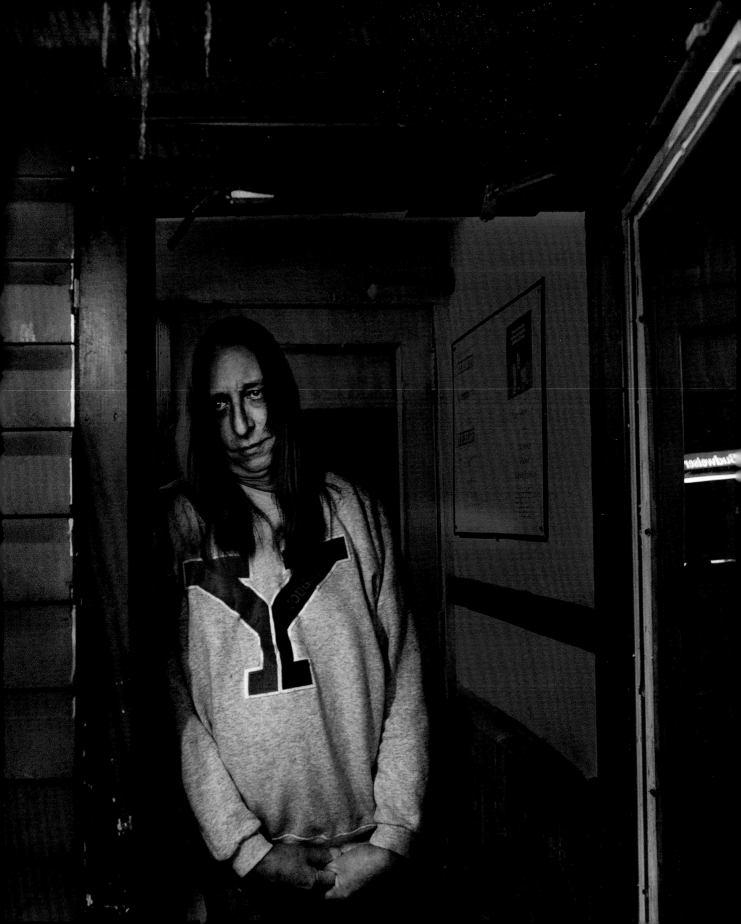

HARRIS MIZRAHI
UNITED STATES

harrismizrahi.com

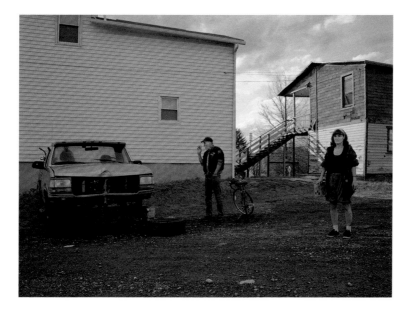

Left: Dee. Above: Conversations with No One.

INSIDE OUT

I began working on this project as an excuse to escape. Battling the deep depression and seductive mania of my bipolar disorder, I would drive as far as I could from home before tiring, much of the time with no thought of returning. The trips were a form of therapy where my own state of vulnerability and desire to be accepted allowed me to sympathize with and photograph the people I met with honesty, empathy, and an intimacy not typically awarded to strangers.

However, the photographs present a dichotomy. Although they may be created with honest intention, they are not factual nor are they intended to be. They ride a line between fantasy and reality, never quite falling to either side. The end result is a story of a place and people that do not truly exist outside of these photographs.

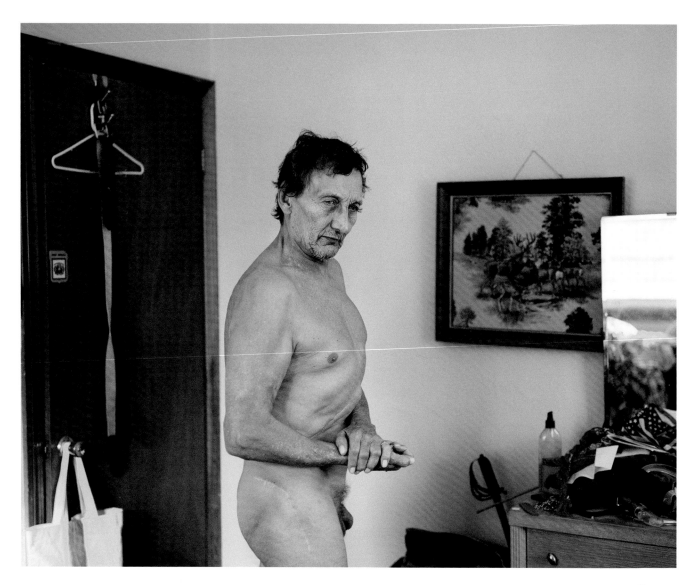

Dave.

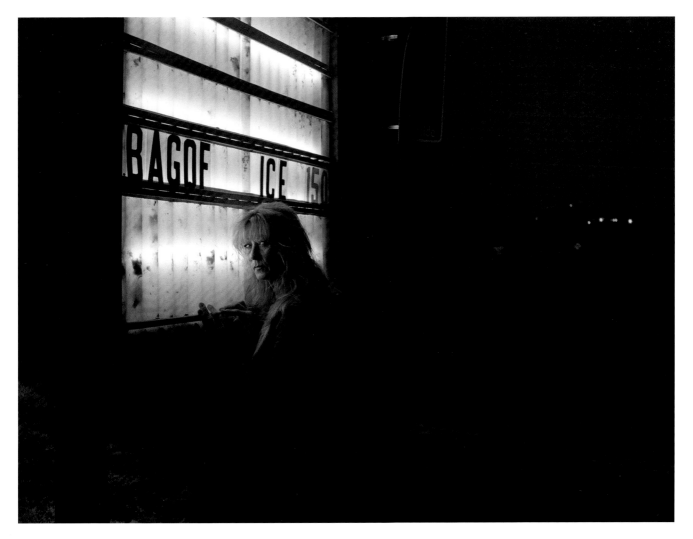

Viviane.

CHRIS DE BODE
THE NETHERLANDS

chrisdebode.com

ZACHERIA AND CLARA

I went to Mozambique to focus on malnutrition. Over a period of two weeks, we visited the hospital's malnutrition ward, where I met Zacheria and his lovely daughter Clara, who is suffering from acute malnutrition. She is going through a very hard time. Not only is she very ill from malnourishment, she also broke her hip. They live far from the hospital. Zacheria is with Clara all the time. They spend every minute of the day together. It is wonderful to see such strong love between father and daughter.

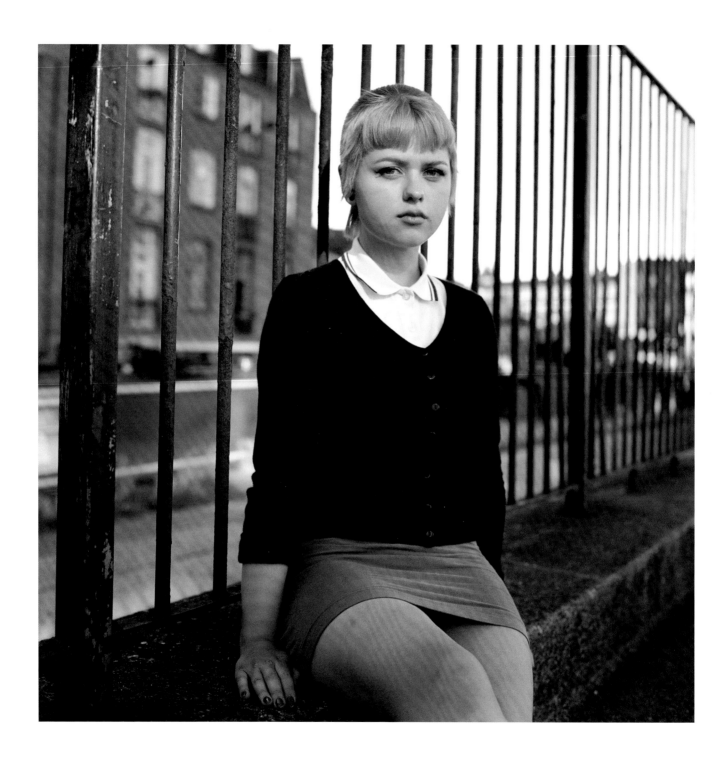

OWEN HARVEY
UNITED KINGDOM

owen-harvey.com

YOUNG SKINHEAD GIRL, LONDON

Skinhead subculture has a long and complex history. The subculture drew influence from the earlier Mod style and originally used music by Jamaican musicians in the 1960s as its soundtrack. Those involved in the subculture had a sense of working class pride, and these attributes were often recognized in both white and black youth growing up across England. In the 1980s, the original skinhead subculture was split into far-right and far-left factions by political affiliations.

Although many skinheads consider themselves apolitical, people outside the group are most familiar with the strongly nationalist leanings of the far-right faction. The distinctive skinhead look went on to be adopted by neo-Nazis and various other racist groups; as a result, many original skinheads felt it was time to abandon their style due to the association.

Still, some true skinheads refused to give up their style and this caused a further divide within the subculture for those with different political stances. This image is taken from my documentation of young skinheads living in the UK. After much media attention throughout the years, I wanted to photograph these young adults who choose to present themselves as skinheads in the current moment.

KENSINGTON LEVERNE
UNITED KINGDOM

kensingtonleverne.com

MYLES

I photographed Myles just before the Cottweiler show at
London Fashion Week. His gaze was strong and arresting;
I knew straight away that I wanted to photograph him.
Here, I tried to create a sense of mystery by under-exposing
the image to create a silhouette effect.

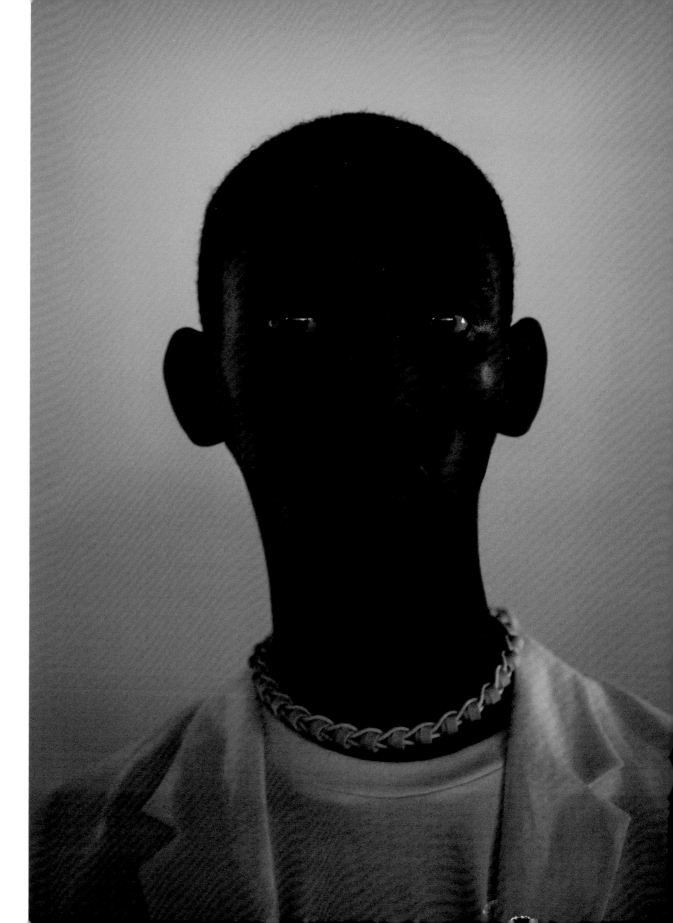

Rama falling in love.
New Delhi, India, 2015.
Hand-painted C-print.

VASANTHA YOGANANTHAN
FRANCE

a-myth-of-two-souls.com

A MYTH OF TWO SOULS

A seven-part series inspired by the ancient Indian epic tale
The Ramayana. Drawing inspiration from the imagery associ-
ated with this myth and its pervasiveness in everyday Indian
life, I am retracing the legendary route from north to south
India. My work is informed by the notion of a journey in time and
offers a modern retelling of this central mythological narrative.

The Cage.

DAVID WAGNIÈRES
SWITZERLAND

davidwagnieres.ch

The small ice seller of Allada.

THE SECRETS OF AYOU

I traveled to Ayou, a small rural village in Benin, with an
NGO. At each step, I try not to commit a misstep that would
ruffle the supernatural forces, bringing the wrath of the
deities on the community. Through this project, I do not try
to explain the cult portrayed, but instead follow a path
through my encounters, perhaps crossing (unknowingly)
the lines of force of this invisible, telluric, parallel world.
My goal is to create humanistic portraits loaded with magic,
intensity, and doubt.

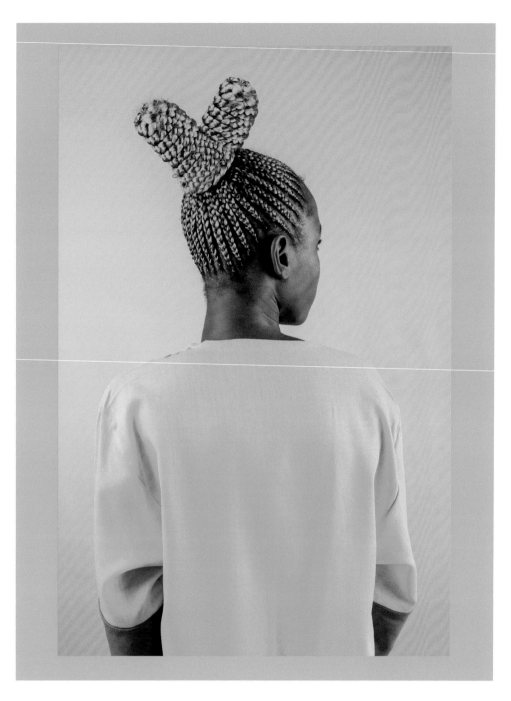

Untitled.

MEDINA DUGGER
NIGERIA

medinadugger.com

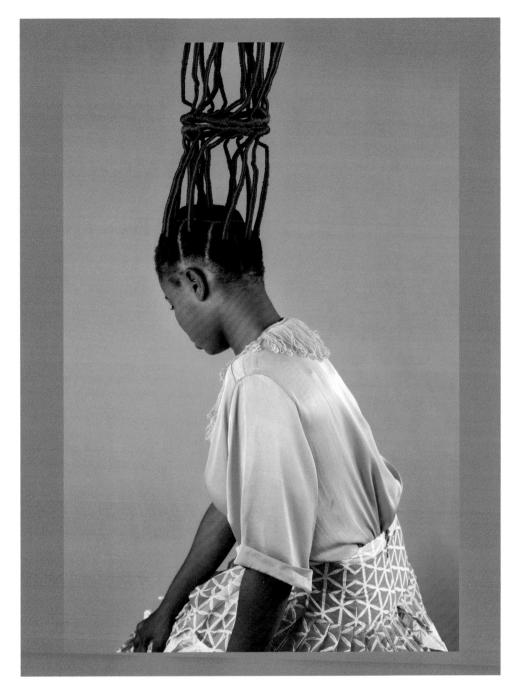

Ode to J.D. 'Okhai Ojeikere
in Color.

CHROMA

Celebrating the hairstyles of Nigerian women through a
fanciful, contemporary lens. The images are inspired by
recent hair color trends witnessed in Lagos and also by
the late Nigerian photographer J.D. 'Okhai Ojeikere, who
photographed over a thousand different African women's
hairstyles.

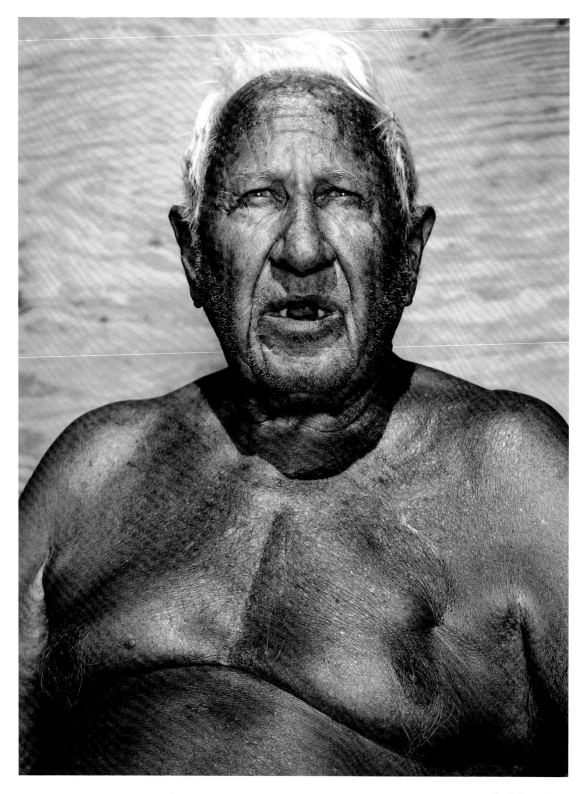

Cecil, Nevada.

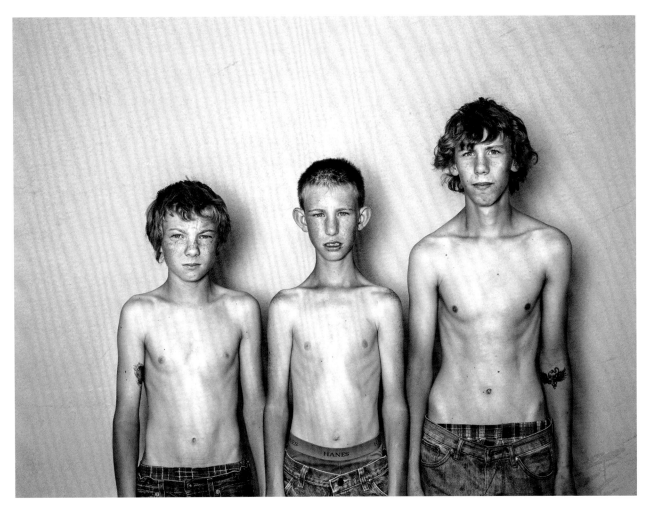

Austin, Randy, and Justin, Nevada.

ROBIN DE PUY
THE NETHERLANDS

robindepuy.nl

IF THIS IS TRUE...

In May 2015, de Puy set off on an 8,000 mile road trip across America on a Harley-Davidson motorcycle. Her most vital equipment was in her saddlebags: a couple of lamps, two cameras and a lighting umbrella. She followed no set route but toured the country looking for distinctive faces to photograph—people of all ages and both sexes whom she happened to meet on her travels. These photographs (combined with self-portraits and landscapes) form a collection that aims to capture a glimpse of today's America.

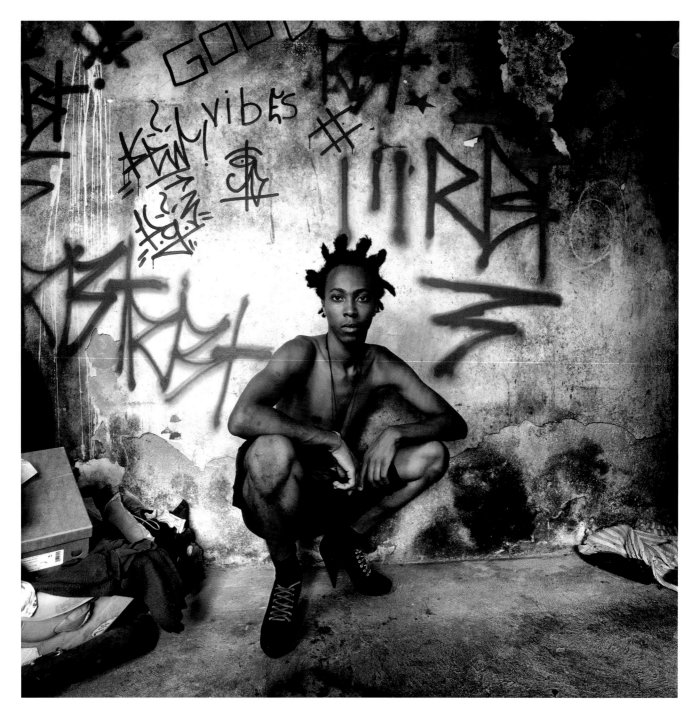

Bruno Rabbit, 19. He lives in the outskirts of São Paulo. This photo was made in his room.

EDU SIMÕES
BRAZIL

edusimoes.com.br

Miquelangelo, 25. He lives in Guajuviras, Canoas near Porto Alegre, in the south of Brazil.

59

Brazil is an extremely violent country. Every year, more than 30,000 young people are murdered for diverse reasons. Of these, 77% are Afro-Descendants. That is to say, an average of 59 young Afro-Descendants are murdered in Brazil every day. This is a series of portraits of those Afro-Descendants, residents of the country's favelas. My work aims to celebrate and highlight this group of people.

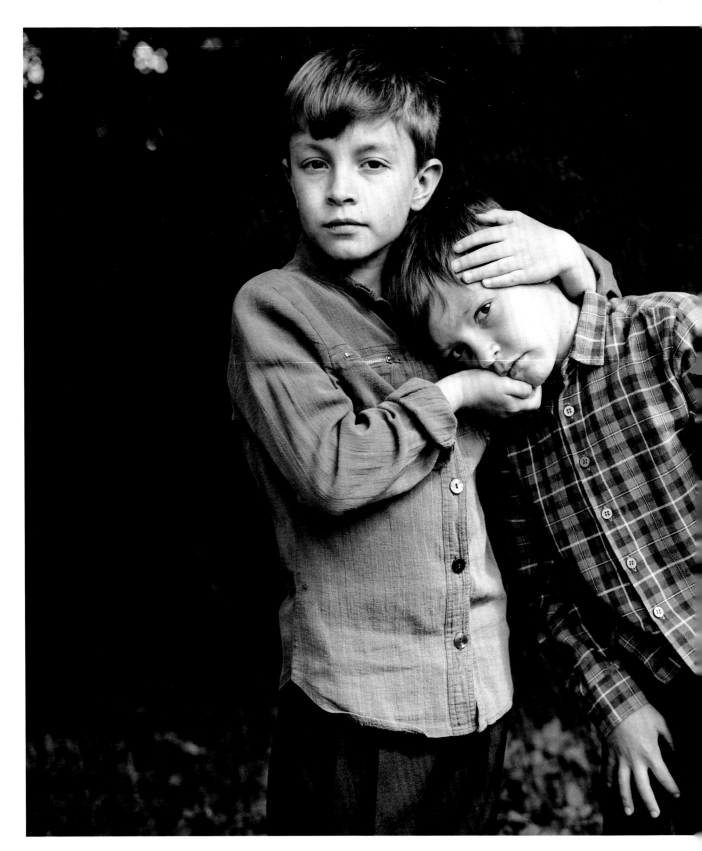

NELLI PALÖMAKI
FINLAND

nellipalomaki.com

SHARED

This photograph explores siblinghood through portraiture. It shows the physical closeness between siblings and simultaneously underlines the uncomfortable feeling of being so close to someone.

Looking at these siblings, we are not only searching for a likeness, but we are also studying their differences and observing the power dynamics. Siblinghood as a theme is intriguing—something so ordinary yet incredibly complex, filled with untold emotions.

Zane and
August, 2016.

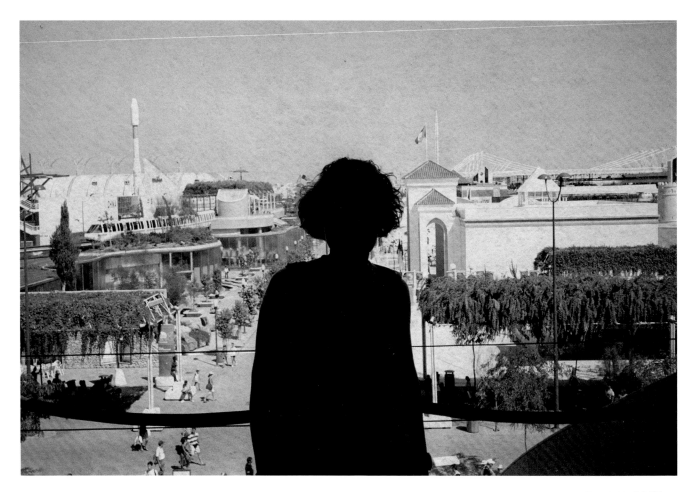

"This Is You" #101.

ALBARRÁN CABRERA
SPAIN

en.albarrancabrera.com

"This Is You" #31. "This Is You" #12.

THIS IS YOU

When we look at a photograph related to our experiences, our intangible and unreliable memories surrender to the printed image. The concrete photographs replace our abstract memories, and our identity is certified by that set of pictures.

Some time ago, a friend gave us some negatives and old postcards he had found inside a picture wallet in the trash. After scanning the negatives, we found they were family portraits taken about 40 years ago by an amateur photographer. We decided to use our own photographs along with the anonymous ones, unifying all of them using the same printing process and thus generating the identity and memories of someone who never existed.

MARINKA MASSÉUS
THE NETHERLANDS

marinkamasseus.com

MY STEALTHY FREEDOM II—IRAN

This project reflects on the forced hijab, the much-hated symbol of oppression for the majority of Iranian women. Every day, Iranians—especially women—defy the regime courageously through small acts of defiance: by wearing their hijab too low, the colors too bright, their pants too tight or their manteaux too short. Together, these constant acts of bravery are affecting change, allowing for slow but visible evolution.

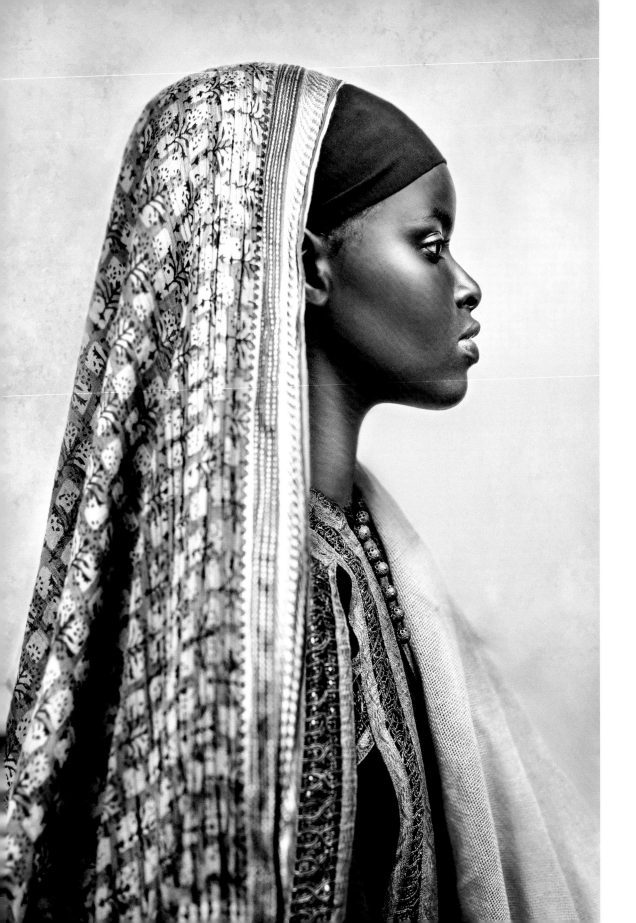

DIASPORA: MUNA: This is a portrait of Muna. Muna is Somalian and moved to Europe eight years ago. Her name is a common one in Somalia: it means "wishes" and "desire" (from the Arabic منية, munyah). For centuries, the West has often gazed at Africa through a lens which distorts the reality of the continent's people and its history. With the current surge of African immigrants in the West, these preconceived notions and stereotypes, unfortunately, often remain prominent. My Zimbabwean husband experienced this when we moved from the African continent to the Netherlands a decade ago. This sparked my interest in how African people live in other places around the world and started this line of inquiry that interrogates how African people are presented in history as well as in the present.

DAGMAR VAN WEEGHEL
THE NETHERLANDS

dagmarvanweeghel.com

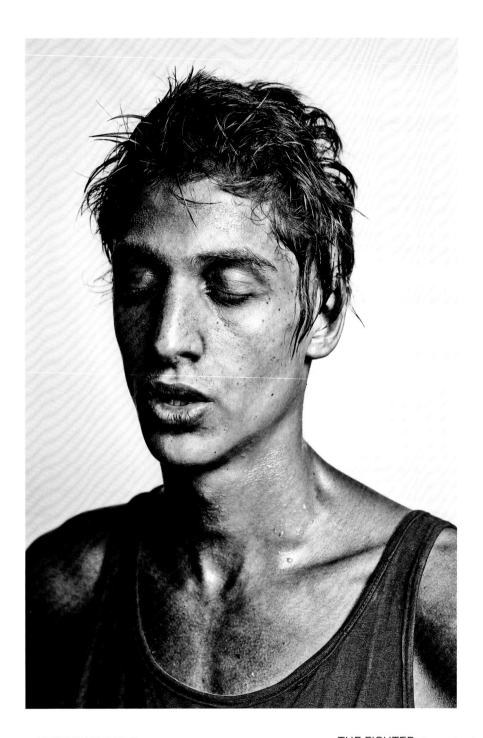

LUIZ MAXIMIANO
BRAZIL

luizmaximiano.com

THE FIGHTER: I spent a few weeks over two months photographing the Champion's Forge, the oldest and largest amateur boxing competition in Brazil. I set up a studio right by the ring, and as soon as the boxers finished their fight, I would photograph them against a white background.

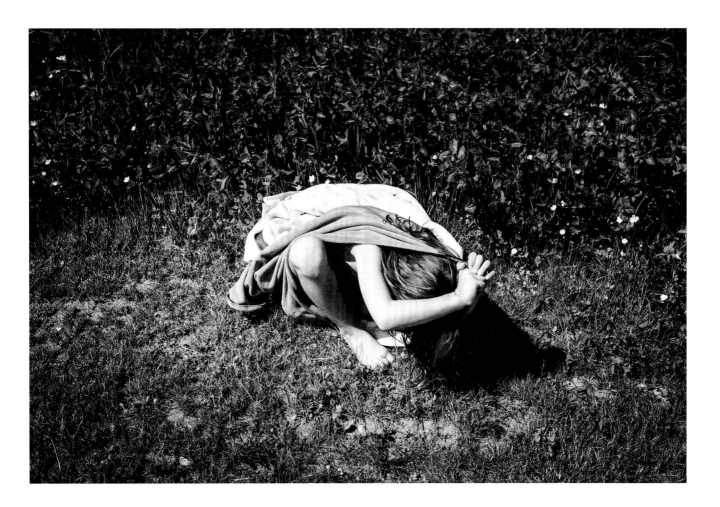

ONGOING: Using my camera, I follow my only son, my father, and the rest of my small, shattered family through their lives and into their intimate spaces. I report what I feel and see. The images are not staged, but are affected by me, as their close relative and the photographer. I am searching for our personal family identity.

RAHEL KRABICHLER
SWITZERLAND

krabichler.ch

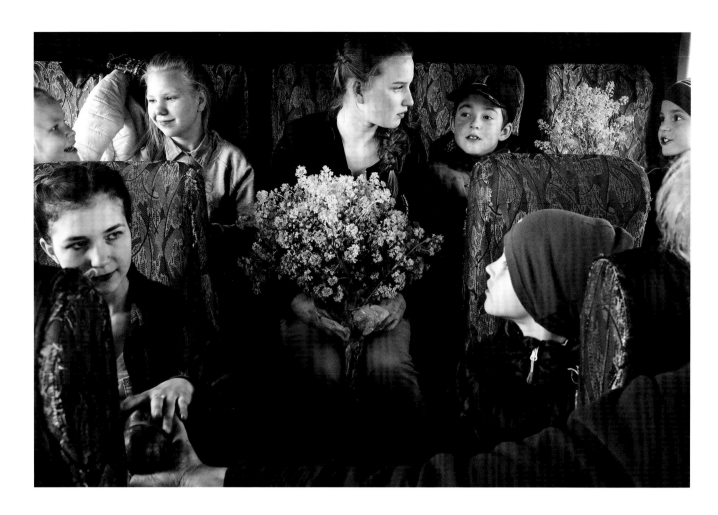

SCHOOL BUS: I took this picture in a national reserve area which is called "the motherland of cranes." Every autumn, thousands of cranes stop there before they fly south. Every spring, children from nearby towns and villages seed a special field for these cranes. Here, the children are sitting on the bus after the seeding ceremony, ready to return home.

ANNA SHUSTIKOVA
RUSSIAN FEDERATION

shustikova.viewbook.com

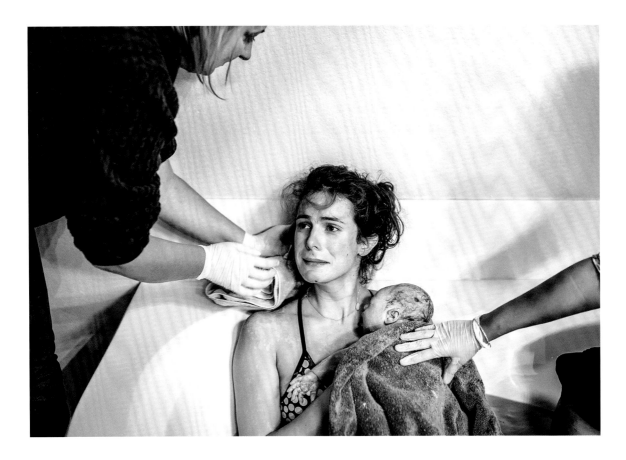

I DID IT: After I was asked to photograph the birth of my niece six years ago, I knew I had found my calling. Birth imagery is emotive, touching, and genuine. I credit my own experiences in motherhood for my desire to connect with the viewer and tell stories about birth with dedication and grace.

LEILANI ROGERS
UNITED STATES

photosbylei.com

TIN TRIBES IN THE GARDEN OF ETHER:

This image, which shows a Sapeur from Congo, is part of a wet-plate collodion photographic series that looks at a number of different subcultures where style and fashion play an important part. Whether for political reasons, issues of freedom, resistance, gender equality, or self-expression, these are cases of individuals standing up against the norms of the surrounding society.

NICOLAS LABORIE
UNITED KINGDOM

nicolaslaborie.com

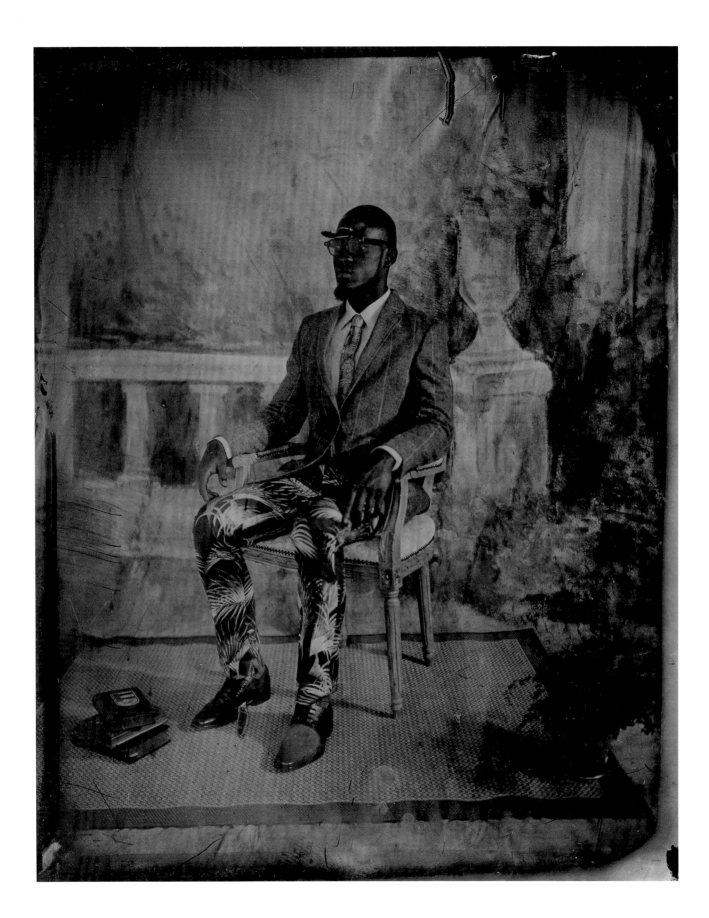

THE BEST OFFER: I shot this portrait while on set for *The Best Offer*, where Geoffrey Rush plays the main character. As the still photographer for Giuseppe Tornatore's film, my job was to take pictures as the scenes were shot. I used a more personal approach for this work, hence the choice of black and white (the rest of the scene pictures were shot in color).

STEFANO SCHIRATO
ITALY

stefanoschirato.it

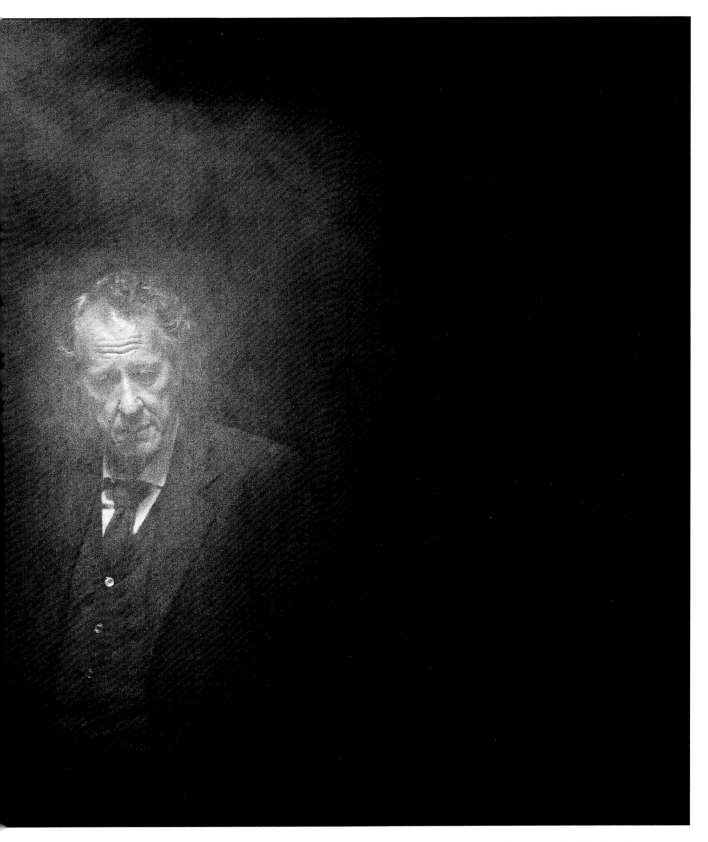

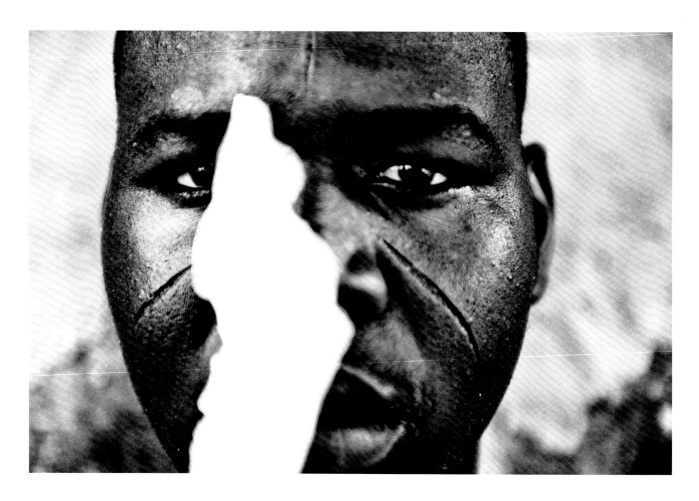

PALM TREE CUTTERS: Adamu, 20 years old. He told me that the most beautiful thing in life is hard work. In Nigeria, we say that those who do not work hard should not eat. My own father died when he was 52 years old: he was a businessman. My grandfather died at 48: he was an officer in the Nigerian army. Today, I am 50. Recently, I photographed ten young laborers and asked them about their lives and what they think about the future. These men love their work and do it with all their hearts.

CLETUS NELSON NWADIKE
SWEDEN

lensculture.com/cletus-nelson-nwadike

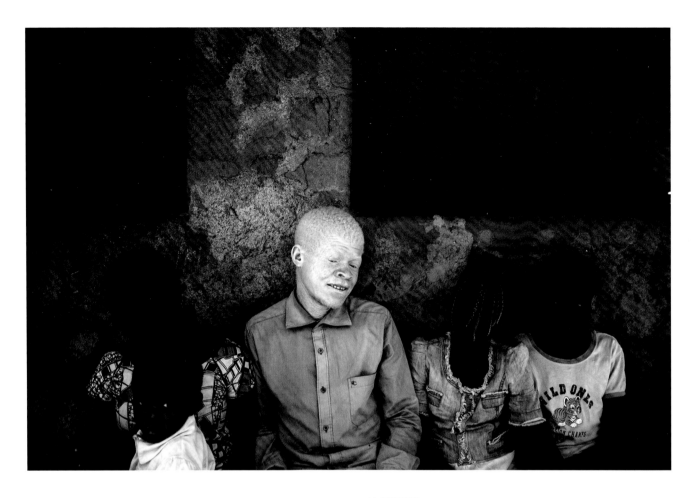

ALBINOS: People believe in the prophecy that says that if you have a piece of an albino (usually their hands, feet or head), you'll have luck or money in life. Beginning in Tanzania, efforts have been made to combat the problem but this has led to further persecution in surrounding countries. In this work, I look at the albinos of Mozambique and Malawi who have suffered discrimination, kidnappings, murders, and vandalized graves.

DANIEL RODRIGUES
PORTUGAL

danielrodriguesphoto.com

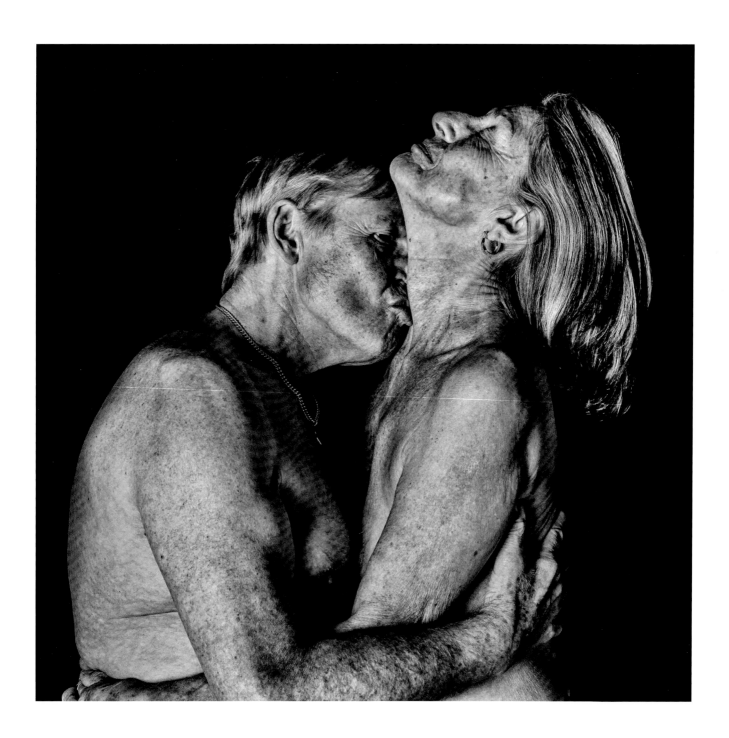

136 - Portrait Awards - Finalist

ETERNAL DESIRE: This photo occurred when Jane and Phil, who are both in their seventies, came in for a portrait shoot. They live life to the fullest, trying new activities and going on adventures. They were very passionate towards each other and asked whether I minded their show of affection. While many people think passion should die out as grey hair comes in, with this image, I wanted to celebrate older age—wrinkles, blemishes, and all—and show that love and passion are age-inclusive.

NICK MOORE
SPAIN

nickmoore.eu

FATOU: This is Dutch model Fatoumata Jaiteh. Fatou's striking profile is really amazing. It immediately caught my eye the moment I saw a picture of her as a fashion show model. Her natural beauty—coupled with this almost classic Egyptian pose—resulted in a wonderful shoot in my Amsterdam studio.

MART BOUDESTEIN
THE NETHERLANDS

martboudestein.com

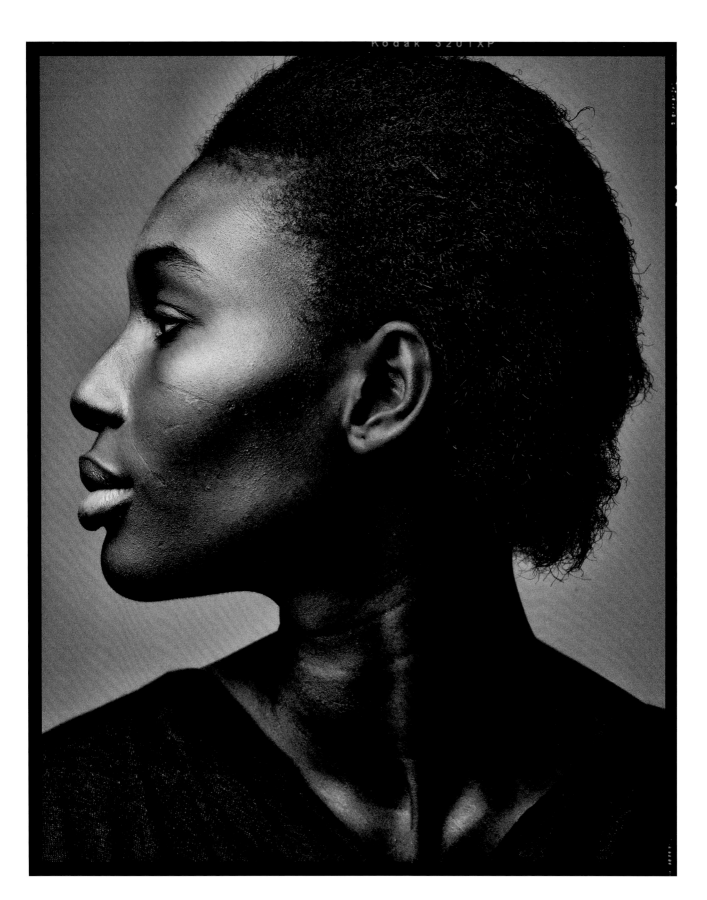

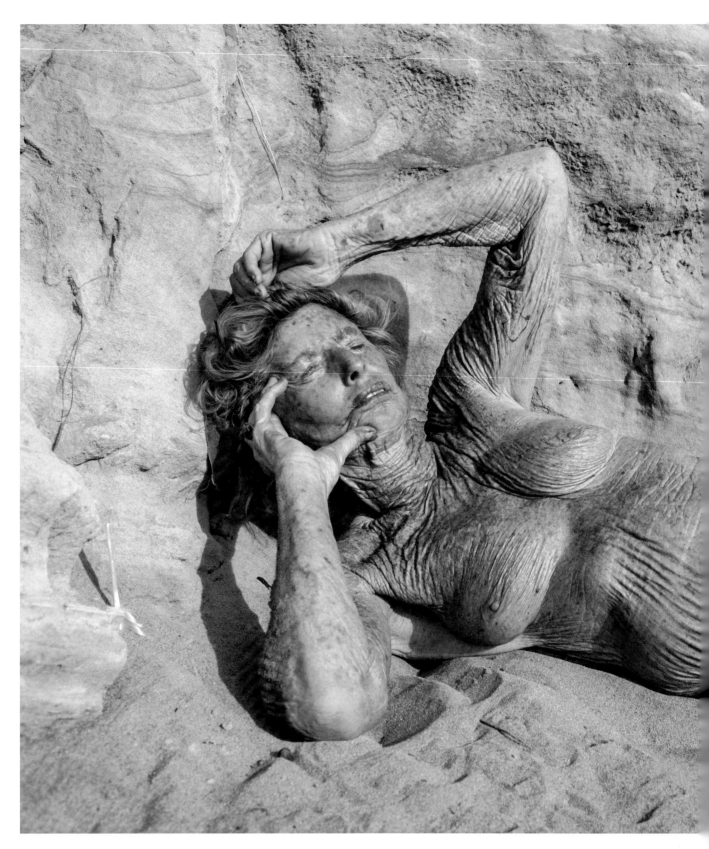

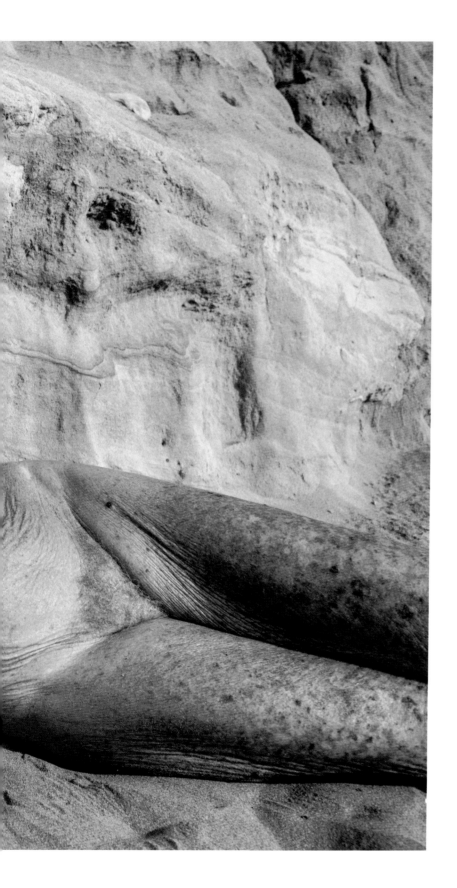

SEA CHANGE: AN ONGOING PORTRAIT:

Carol Schuldt is a dynamic, strong, and fiercely independent 83-year-old woman. Her weathered body (which has been through hip-replacement surgery and several bouts of cancer) houses a youthful spirit that is energized and sustained by her intense connection to the sun and the ocean. Carol is a fascinating character and, I believe, a potential inspiration to many—especially older adults who fear that age will slow them down.

JESSICA EVE RATTNER
UNITED STATES

jessicaeverattner.com

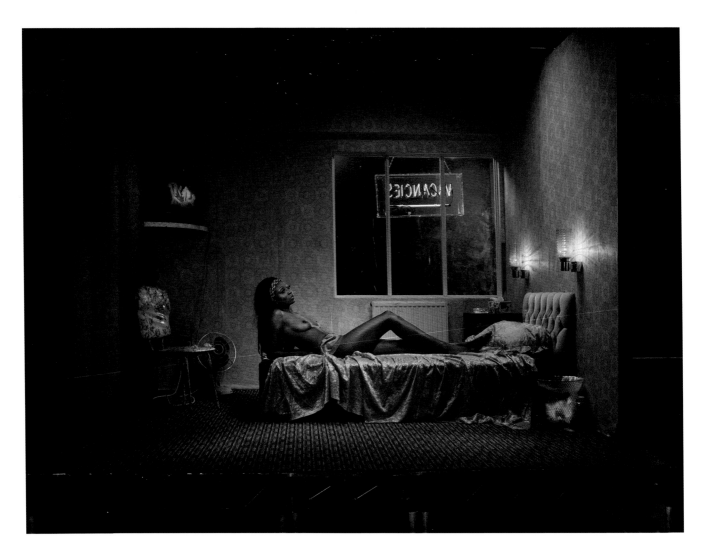

SHADAIT, ESCORT: "The Act" is a body of work on women in the sex industry. I created the stage sets according to the girls' lives. In this case, Shadait began escorting when she became homeless.

JULIA FULLERTON-BATTEN
UNITED KINGDOM

juliafullerton-batten.com

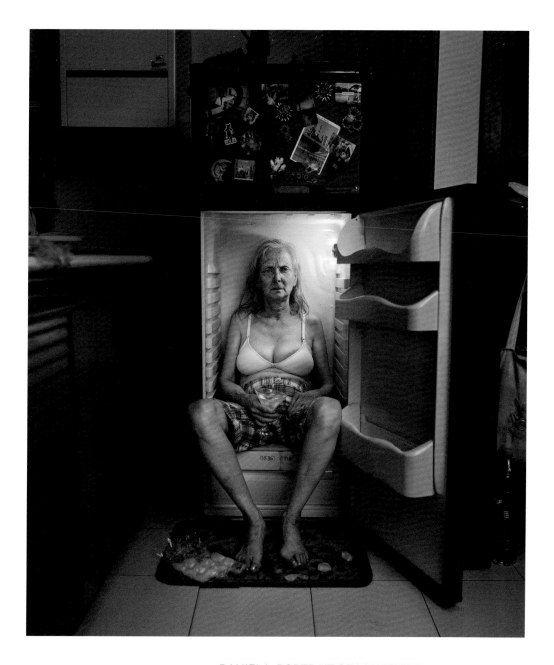

DANIELA: PORTRAIT OF MY MOTHER: I started photographing my mother to learn how to use a camera; I continued doing so to spend time with her. Photography is a bridge in our relationship, a time where we connect and discuss things. "Of course, some painful cracks developed in my soul, and I lived away from reality for who knows how long." This is one of the sentences my mother wrote in her diary and is an important reference point for this work.

NIKO GIOVANNI CONIGLIO
ITALY

nikoconiglio.com

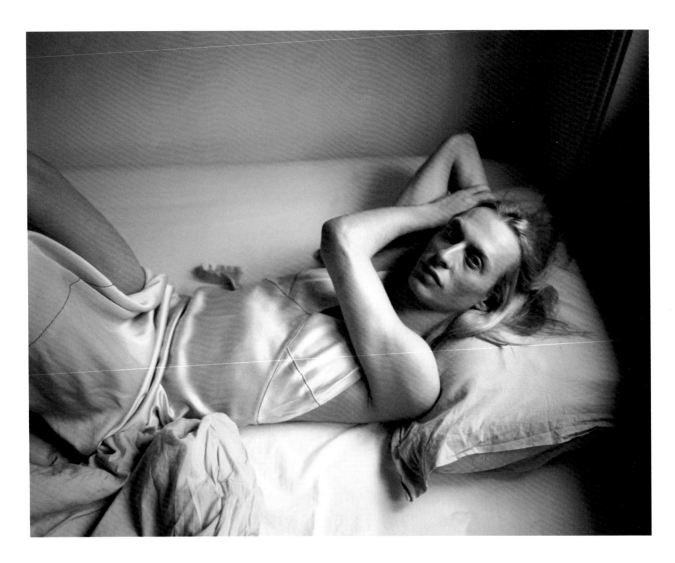

GORAN IN BED: "I woke up like this." When I'm shooting portraits, I'm looking for eccentric people, people who dare to be different or have something to say. Goran is a cross-dresser and doesn't care how people want to "categorize" him. Here is Goran in bed. Fortunately, Amsterdam allows us to be who we are so we can roam freely. We're blessed in this city.

RAMONA DECKERS
THE NETHERLANDS

ramonadeckers.com

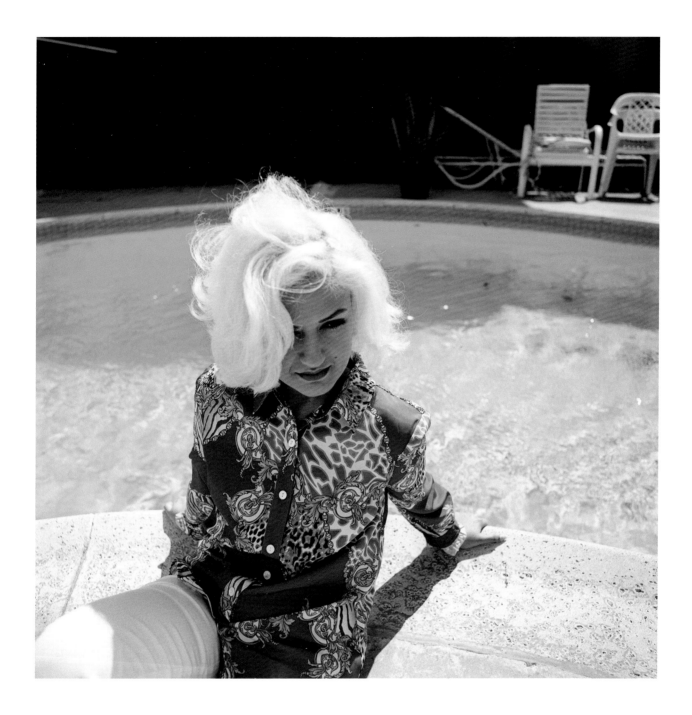

EMILY BERL
UNITED STATES

emilyberlphoto.com

MARILYN: I moved to Los Angeles in 2012 with a television writer and an actor, both in pursuit of the "Hollywood Dream." Soon, I started to notice the face of Marilyn Monroe everywhere. I began to think of Marilyn's story as a symbol for this place: the promise and peril of the Hollywood Dream, as represented in a single person's life.

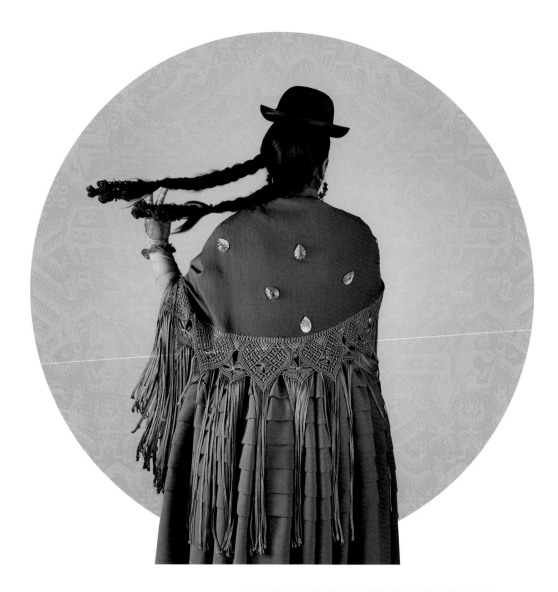

CHOLITAS, THE REVENGE OF A GENERATION: In the familiar Spanish, "cholita" means a young Bolivian woman, often someone who identifies as a member of the indigenous culture. For decades, however, they suffered from severe racial and social discrimination. The objective of this series is to counterbalance the stereotype of the traditional Bolivian woman while reconsidering the (dated) Western vision of this population.

DELPHINE BLAST
FRANCE

delphineblast.com

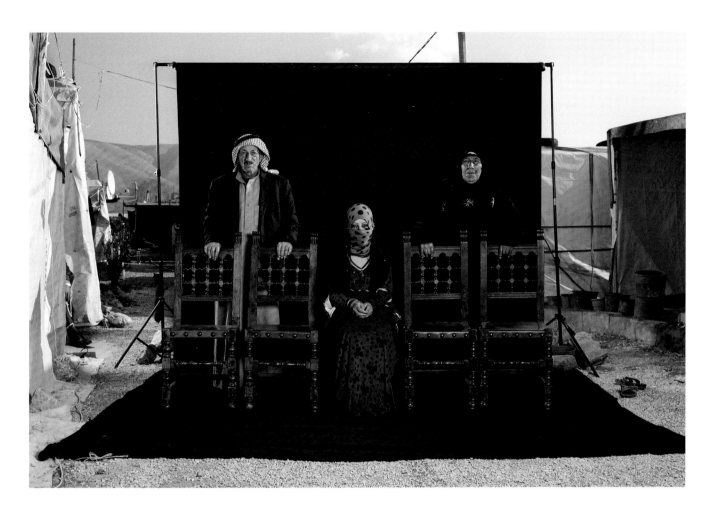

LOST FAMILY PORTRAITS: Owayed's family. "I was forced to leave my four sons behind. I was getting WhatsApp messages from them, but then one day the messages stopped coming." These portraits tell the story of those who have lost relatives in the Syrian war—the missing symbolized by the empty chairs or spaces—and have made their way to refugee camps in the Bekaa Valley, Lebanon.

DARIO MITIDIERI
UNITED KINGDOM

mitidieri.com

IN THIS PLACE: Life feels static in the housing estates of central Scotland. This series tells the story of people and place, family and home, touching on issues of social and personal inertia within our environment. It revisits three siblings and traces the narrative of their lives. The "place" explored here is both mental and physical: where we put ourselves and where we are put, sometimes by others and sometimes by circumstance. What puts us there, what keeps us there, and do we want to be there? These are the central questions.

MARGARET MITCHELL
UNITED KINGDOM

margaretmitchell.co.uk

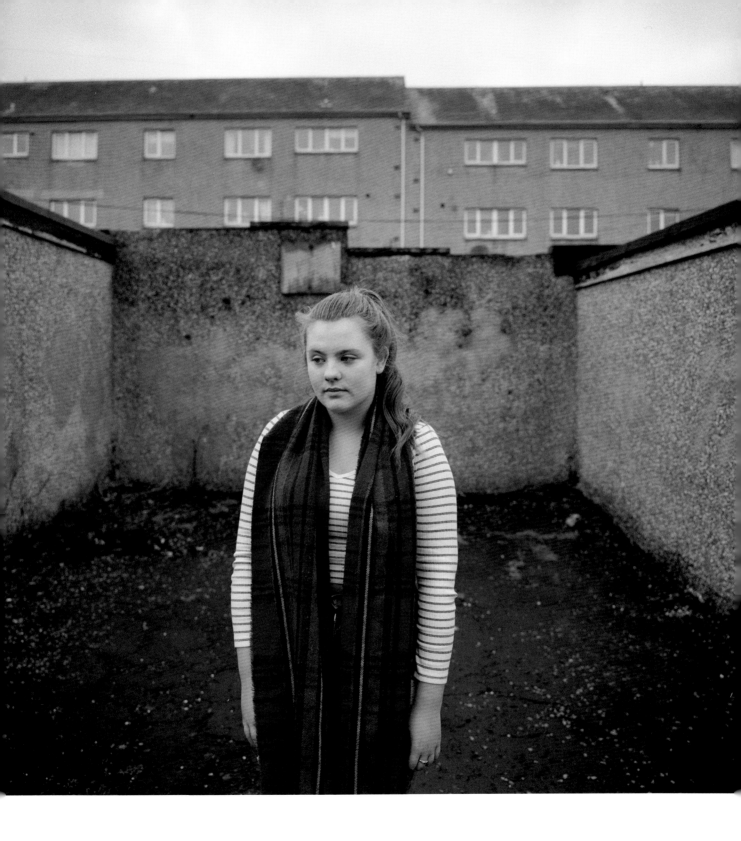

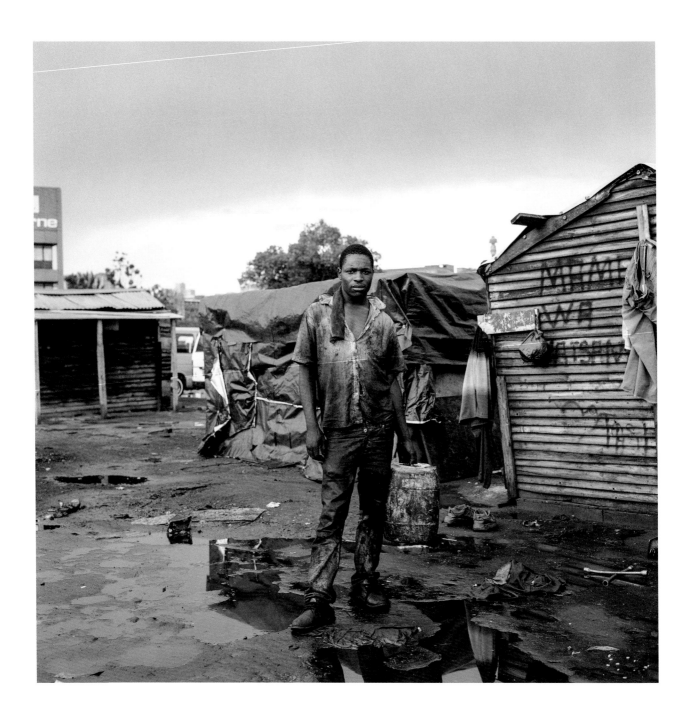

CLAUDIO RASANO
SWITZERLAND

rasano.com

EVERYONE LIVES IN THE SAME PLACE: This man is a taxi mechanic in Johannesburg. Using portraits and landscapes, I reveal the fragile side of life in South Africa. When I begin such work, I always spend a few weeks driving and walking around the neighborhood. The results testify to an immediacy—an instantaneous and honest encounter that highlights my subject.

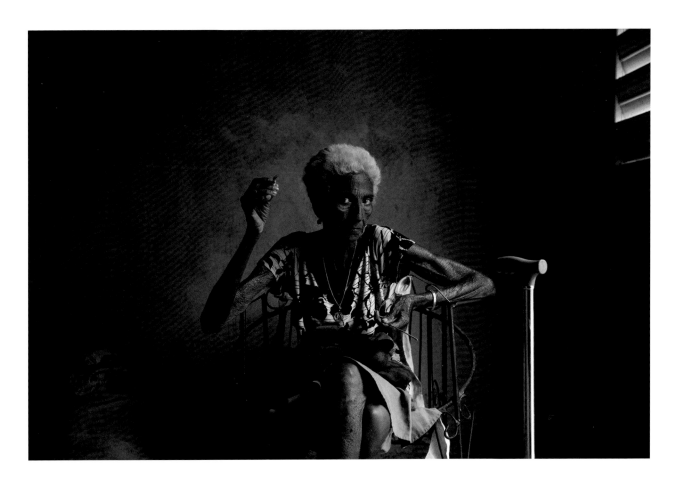

THE VOID WE LEAVE: In 2014, a chance encounter led me to meet the members of an aging community living in a crumbling apartment complex in the town of Cienfuegos, in central Cuba. Although approximately sixty years of age separate us, we created a bond, and I would go back to visit them a few times each year. As time passed, I returned to find empty apartments. Today I understand the urge I had to take their portraits in the first place. I use photography to confront my greatest fear—time—and my fear of passing away. I was hoping that the camera, with its remarkable ability to freeze time, would be able to help me remember them.

ODED WAGENSTEIN
ISRAEL

odedwagen.com

ANNA AUTIO
FINLAND

annaautio.com

THE DROWNED: These photographs and objects were found in the Mediterranean Sea, on and around the drowned bodies of refugees striving to reach Europe. The objects are used by Italian authorities as clues in their attempt to identify the drowned. To many, the drowned refugees appear only as increasing statistics in the pages of daily newspapers. Behind every number, however, lies a world of suffering.

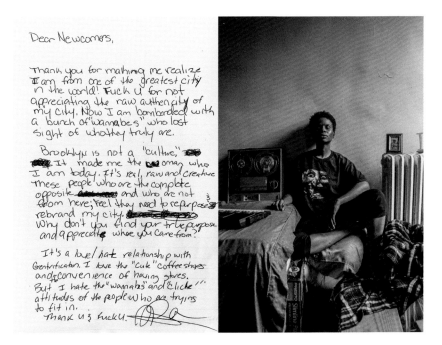

Dear Newcomers,

Thank you for making me realize I am from one of the greatest city in the world! Fuck U for not appreciating the raw authenticity of my city. Now I am bombarded with a bunch of "wannabes" who lost sight of who they truly are.

Brooklyn is not a "culture," ~~It~~ It made me the ~~woman~~ who I am today. It's real, raw and creative These people who are the complete opposite ~~and~~ and who are not from here; feel they need to repurpose; rebrand my city. ~~~~ Why don't you find your true purpose and appreciate where you came from?

It's a love/hate relationship with Gentrification. I love the "Cute" coffee shops and convenience of having stores. But I hate the "wannabes" and "cliche'" attitudes of the people who are trying to fit in.
Thank u & fuck U.

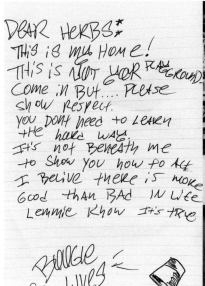

DEAR HERBS:
THIS is MY HOME!
THIS is NOT YOUR PLAYGROUND.
COME iN BUT.... PLEASE
SHOW RESPECT.
YOU DONT need to LEARN
the hard WAY.
IT's not BENEATH me
to SHOW YOU how to ACT
I BELIVE there is MORE
GOOD THAN BAD IN LiFe
Lemmie KNOW iT's TRUE

BOOGIE
LIVES

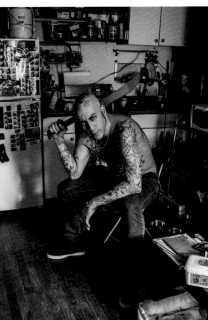

THE ORIGINAL NEW YORKERS:
These images are part of an ongoing portrait series of New York natives who have been affected by gentrification. The subjects were photographed in their homes or workplaces and asked to submit a handwritten note either depicting the way gentrification has affected them personally or an "open letter" addressing newcomers to New York City. The unedited note is then positioned next to the portrait in diptych format.

HARUKA SAKAGUCHI
UNITED STATES

harukasakaguchi.com

YOUNG MEN, WORST FEARS:
Gabriel Harvey. Worst fear:
isolation. While mentoring several
young men at North London's
Arsenal Football Club, I noticed
newspaper reports about the
deaths of local youths in knife-
related stabbings. I discussed
these issues with the young men.
I discovered that absent fathers,
gangs, childhood poverty, and a
dearth of male role models was
a theme commonly running
through their lives, and so this
project was born.

JILLIAN EDELSTEIN
UNITED KINGDOM

jillianedelstein.co.uk

JOE PUGLIESE
UNITED STATES

joepug.com

PRAY L.A. / SUNDAY BEST: A series of portraits executed on a single Sunday morning at the First Baptist Church of Los Angeles, before and after congregants attended morning services. The resulting series was part of a larger portfolio that showcased the many ways people pray and worship in L.A. today.

STREET PHOTOGRAPHY AWARDS

"Photograph the world as it is.
Nothing's more interesting than
reality."

Mary Ellen Mark

HAKAN SIMSEK
BELGIUM

hakan.simsek.be

OUT OF BREATH

I started questioning my identity from a very early age.
My parents immigrated to Belgium from Turkey, offering
me a double nationality. But I was always asked to choose
one of them; I have always had the feeling of being an exile
wherever I go. Maybe more than the location I am living, the
place where I will be buried will define who I am, in the end.

ALBERTE A PEREIRA
SPAIN

alberteapereira.com

FRAGMENTS

One of the main axes on which street photography pivots is the observation of people's behavior, especially in urban spaces. These photos are a sample of small gestures of people absorbed and decontextualized from their surrounding environment. This is my vision of the street separated from the decisive moment. Instead, I look for the essential; for silence and solitude amidst the usual urban noise.

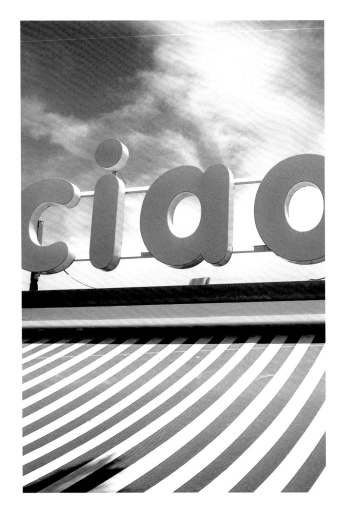

Ciao.

ANTONIO PRIVITERA
ITALY

antonioprivitera.com

Skeleton.

LA NOSTALGIA

I love street photography. It is my way to understand this world. Here, I developed my work between the images and the people, without rules or purpose—instead, witnessing the candid moments during a daily stroll. I fell in love with the solitude; it was so natural to follow these humans during their holiday, their magical "summer break." The beach is a world apart and this is my little story about it.

NY.

Lines.

MOIN AHMED
BANGLADESH

moinuddinahmed.com

THE MAN'S STARE

This photo was taken at the Tongi Railway Station in Gazipur, Bangladesh. I arrived to shoot in the early morning and spent a good amount of time waiting for the right moment. Then, as a train was coming from Dhaka towards another city, it stopped at the platform for 5 minutes to exchange passengers. There was a huge amount of rain falling. When the train reached the platform, suddenly I found a pair of curious eyes looking at me through the window. On the right, a black umbrella had been put out for protection from the water. The mist on the glass and the curious eyes created a dreamy environment filled with questions.

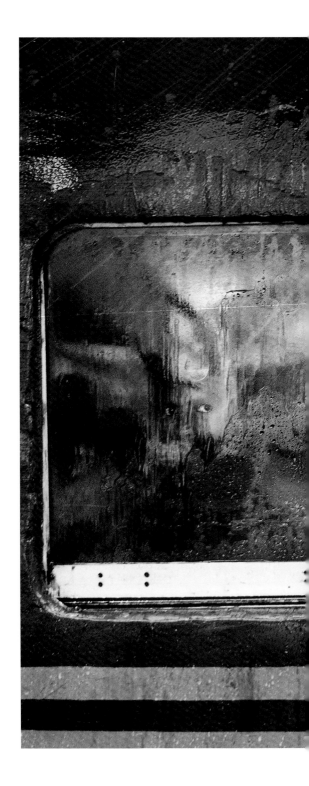

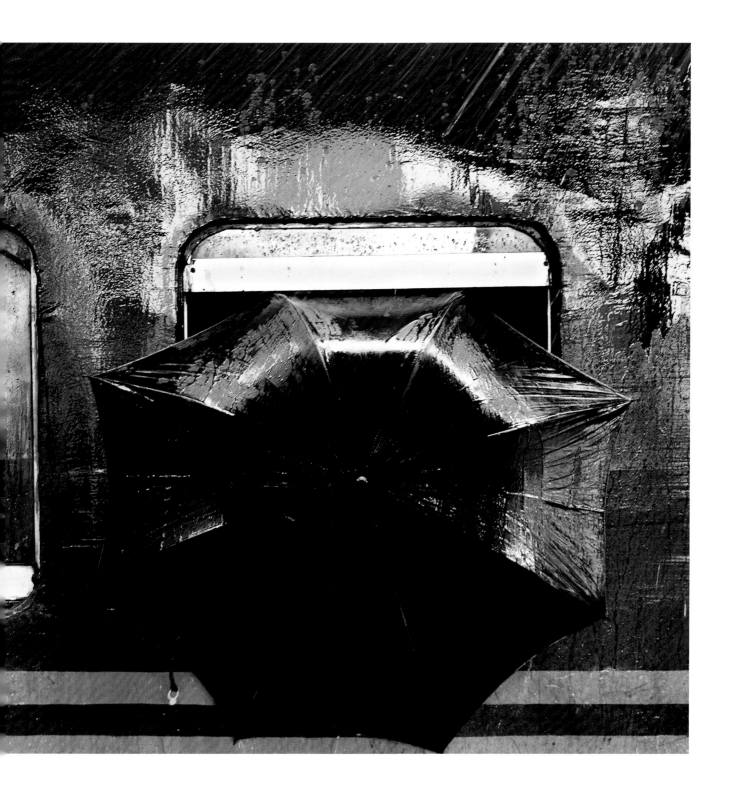

ARTYT LERDRAKMONGKOL
THAILAND

artytphotography.com

THE LITTLE ONIONS

This photo was taken while I was on vacation in Japan with my family in March 2017. The place, Awaji Island, is famous for having the sweetest onions in the country. I like how the color of the clear blue sky contrasts with the orange onion, and especially with the mysterious orange hair of the girls.

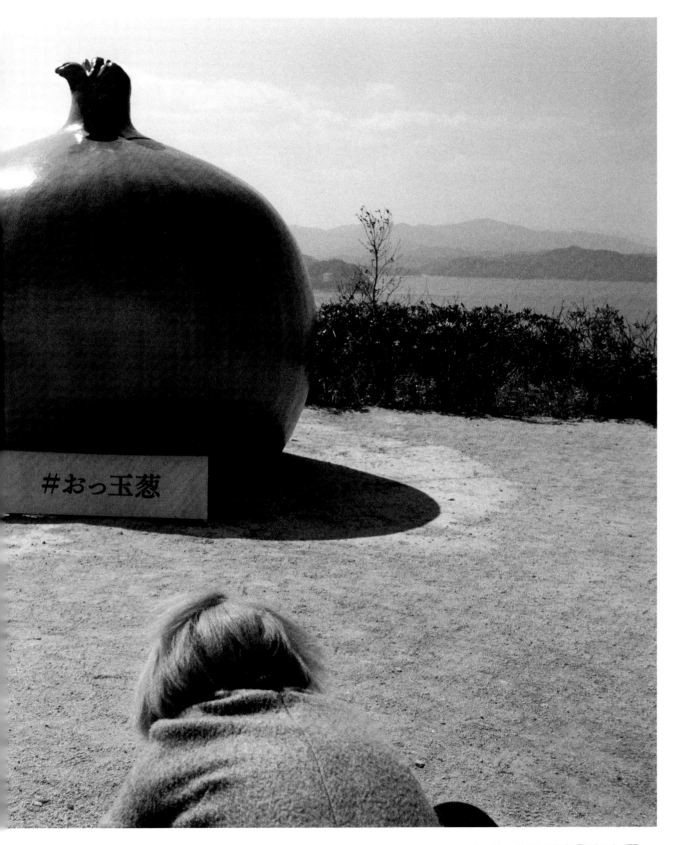

#おっ玉葱

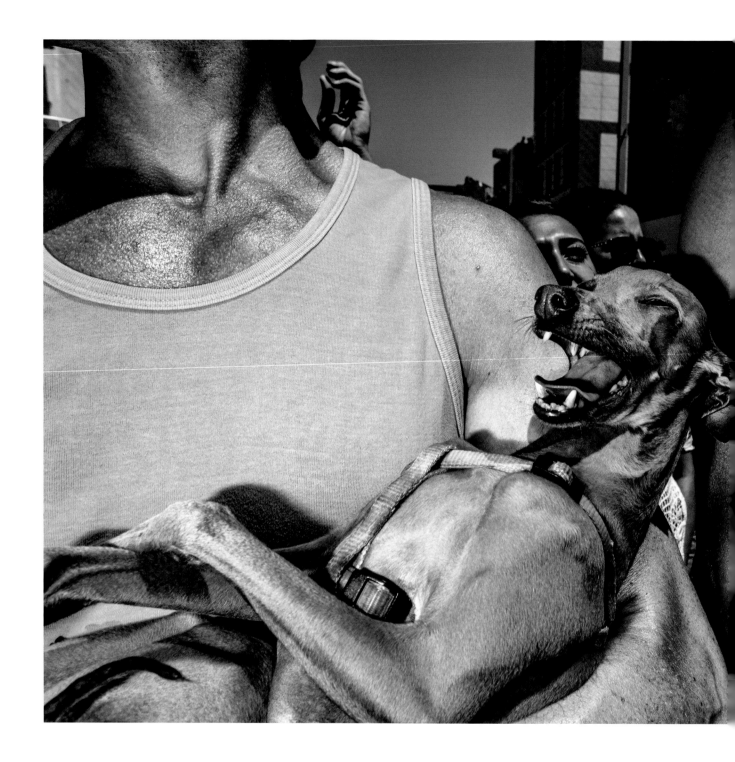

ILAN BURLA
ISRAEL

flickr.com/photos/ilanburla

DOG FUN

This picture was taken on the seaside near Tel Aviv, Israel. While I was wandering along the beach, I couldn't resist the satisfied look on this dog's face. I love the combination of colors and texture in this photograph, and the dog's expression makes me smile. Humor is an element I love to include in my photography, whenever possible.

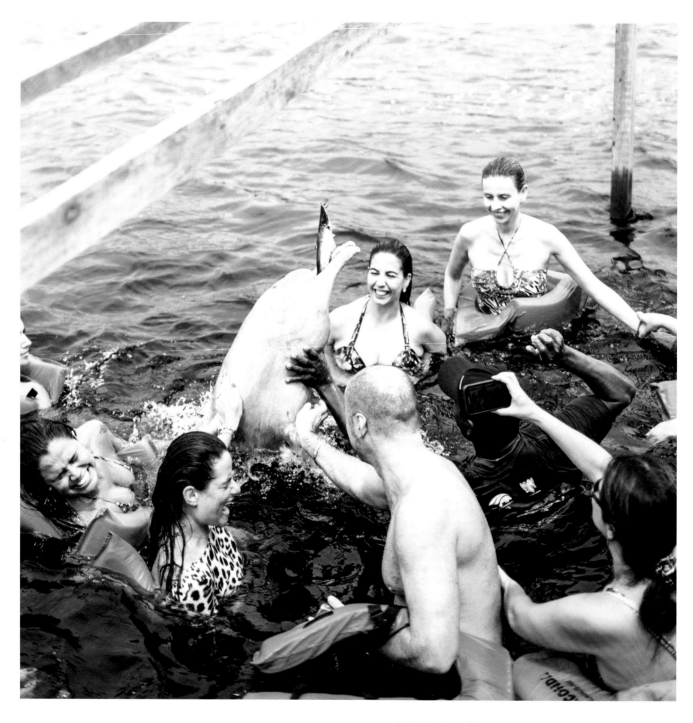

A dolphin being fed so it will jump out of the water. As it eats, the tourists can swim up to it, touch it, and take photos.

FERNANDA FRAZÃO
BRAZIL

fernandafrazao.com

AMAZON B-SIDE

In the last decade, the Brazilian middle class increased its expenditure on tourism by 277%. Leisure travel became more frequent and more accessible to a wider public. Traveling for pleasure is like a celebration, and tourists often vibrate in this frequency of pleasure and joy. My photo-essay is a portrait of the elusive feeling sought during a middle-class journey on an all-inclusive cruise ship sailing along the Black River in the Brazilian rainforest.

JUTHARAT PINYODOONYACHET
UNITED STATES

poupayphoto.com

UN-ORGAN

There are little surprises hidden everywhere, often escaping our notice. This photo series focuses on different aspects of the human body in minute detail. I found that these half-living fragments become special when not fully seen, so I shined a spotlight on them.

ETIENNE BUYSE
BELGIUM

etiennebuyse.eu

BREAK TIME

Waiting for a bus.
Resting for a while, thinking of nothing, or just about what
really matters.
Days go by. Sitting down and wondering about everyday life.
Dodging the routine, the absurd.
In short, a break time.
The real world? Often there is fear, chaos. Or boredom.
Everywhere there are screens, like shields of glass: screens
of televisions, computers, phones…
Everywhere screens—not to mention the camera screen—
as if to glaze over the real.
Putting it in a box to protect ourselves from it, to disguise it,
or to be entertained.
And sometimes, to try to enchant the real.

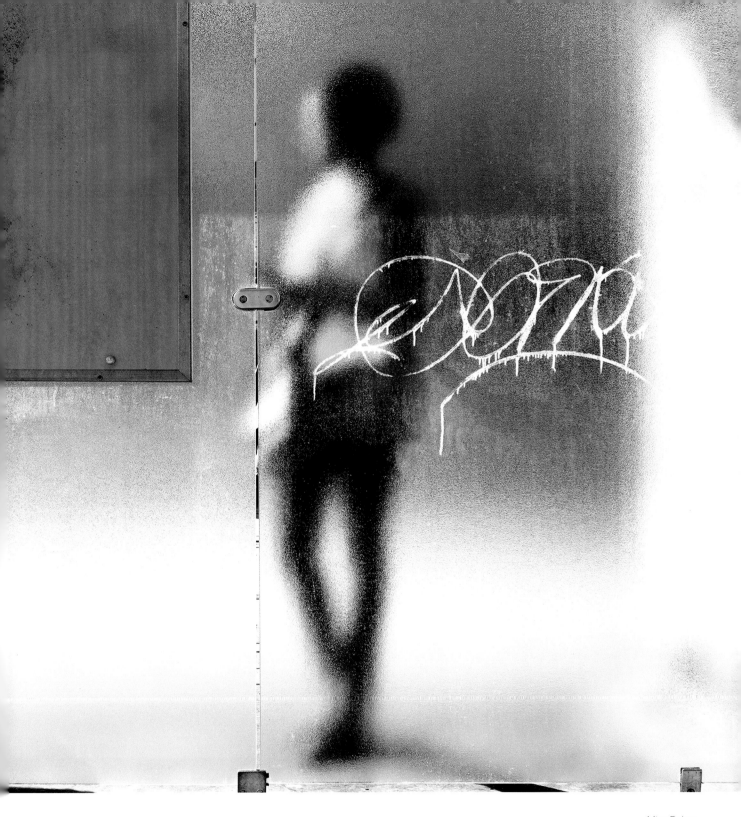

Miss Dakar.

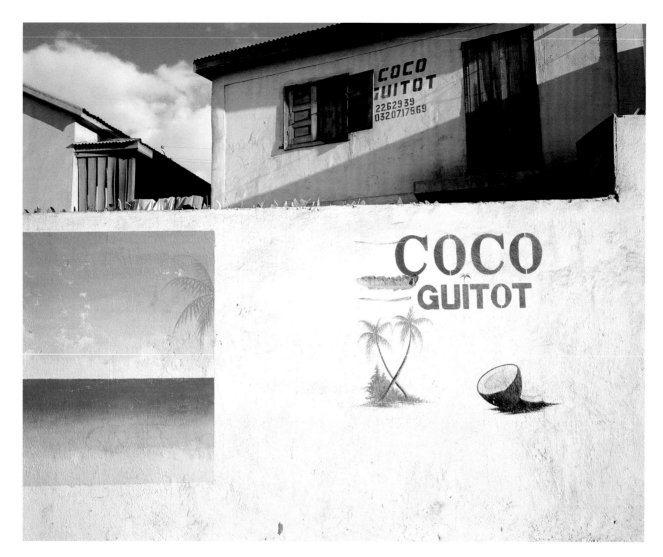

Coco Guitot.

JANICE LEVY
UNITED STATES

janicelevyphotography.com

Zebu on Market Day. Zebu are a variety of cow that are very common on the island.

OUT OF PLACE

Famous for its lemurs, and notorious for destroying their habitat, the island of Madagascar was not much of a tourist destination when I first arrived in 1992. It was remote, mysterious, and incredibly beautiful and I came back for five consecutive years. In 2001, when I finally returned after some time away, I found again many of the people I knew from previous years. But despite the familiarity, things had changed. The island was now full of visual anomalies that had either not been there or not been evident to me before. After shooting in black-and-white, I switched to color to capture what I was seeing: namely, the irony and illusion of Madagascar's infiltrating consumerism and the isolation I sensed because of it.

MARCO GUALAZZINI
ITALY

marcogualazzini.com

THE GIRLS OF MOGADISHU ARE HEADING BACK TO THE BEACH

A man carries a huge hammerhead shark through the streets of Mogadishu. Somalia has an emblematic role to play in any attempt to understand the refugee crisis today, because this country on the Horn of Africa, together with Syria, is the starting point for a large contingent of the refugees who are fleeing to other parts of the world in search of asylum.

Yet within the country, from Bosaso to Dolow, the desire for change is palpable everywhere: girls from Mogadishu go to the beach; beauty parlours and video-game arcades are opening up. People want to start living again, and to do so they are prepared to stand up to the dictates and threats of al-Shabaab, the country's militant jihadi group.

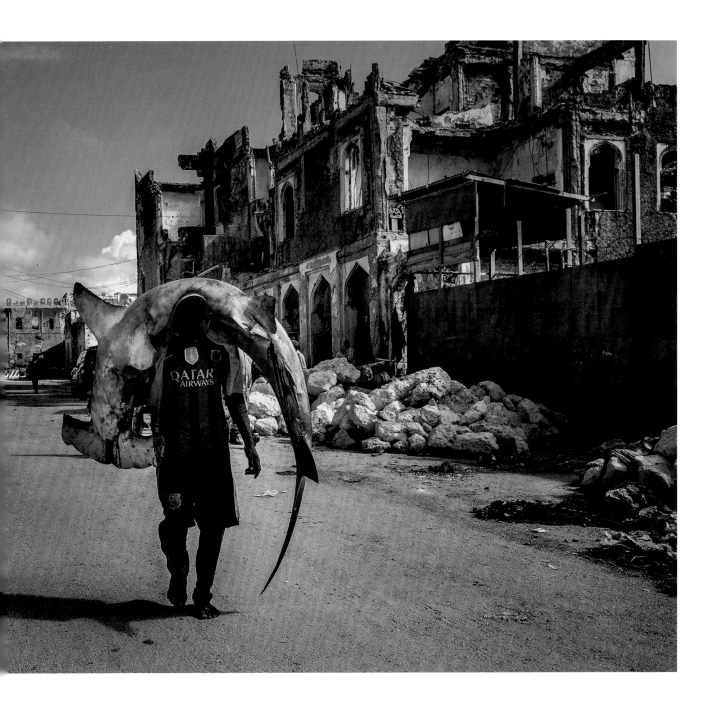

Leadenhall091115.

STREETMAX 21
UNITED KINGDOM

500px.com/streetmax21

OldBailey030717.

050310-030717

I try to choose architectural backgrounds against which
I can display separated figures, distributing or choreo-
graphing them across the frame. The architecture becomes
an almost non-referential space, incidental to a scene or
situation that may or may not evolve within it. Often these
isolated figures don't have to be interesting in themselves,
so long as they create a narrative tension with the others.
Finally, it's important that there is an element of movement—
everything must appear to be changing and in flux while at
the same time retaining a spatial integrity.

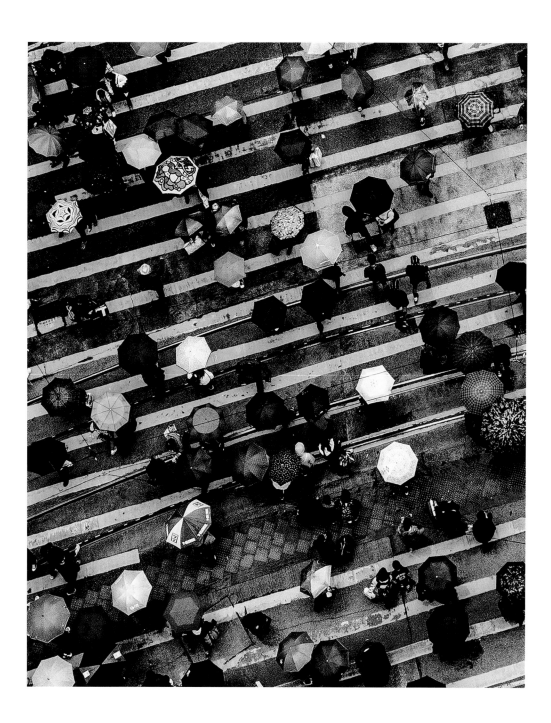

PABLO WEBER
UNITED STATES

lensculture.com/pablo-weber

UMBRELLA REVOLUTION: It was the beginning of a typical rainy day in Hong Kong. The sky was grey and gloomy, the drops of rain fine and dense, the streets were bustling with people hurrying towards cover. Hoards were traversing the famous Causeway Bay crosswalk armed with umbrellas and rain boots. The yellow zebra stripes under them glistened. I ripped my camera out just in time to capture the magical moment. Success.

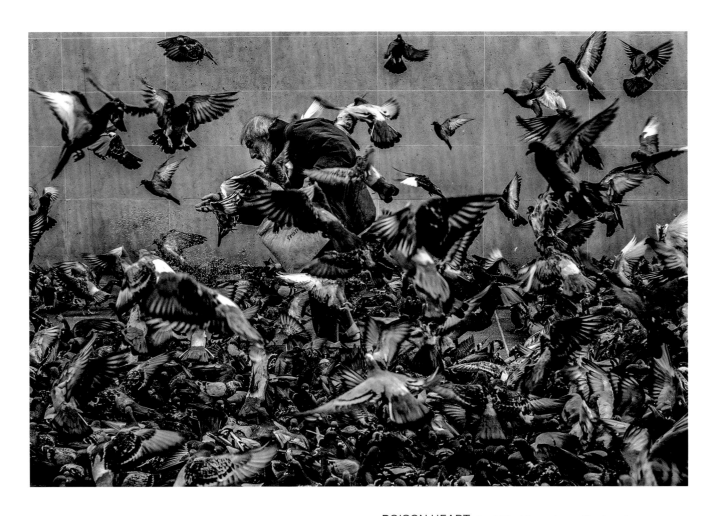

POISON HEART: Just like Vincent van Gogh, who designated himself a "peasant painter" and believed that the essence of art lies in seeing the extraordinary in the ordinary life, I believe that beauty is hidden in the simplest moments. Grace and elegance emerge from chaos when you have eyes to see and a heart that allows you to understand.

ALEXANDRE GRAND
BRAZIL

alegrandretratosfemininos.com.br

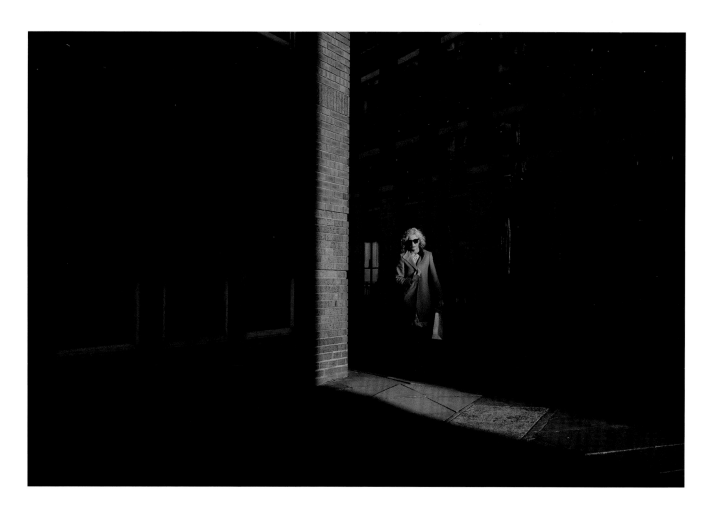

STAGE OF LIGHT: "We all have to walk through the shadow in order to find the light." I believe that everyone, not only me, has had both good and bad experiences in their lives. All of the pictures that I have photographed reflect my emotions, my feelings at that moment, and my experiences. I want to present this work as a runway of life, a reminder to be strong and overcome difficulties in the future.

TAN KRAIPUK
THAILAND

tankraipuk.com

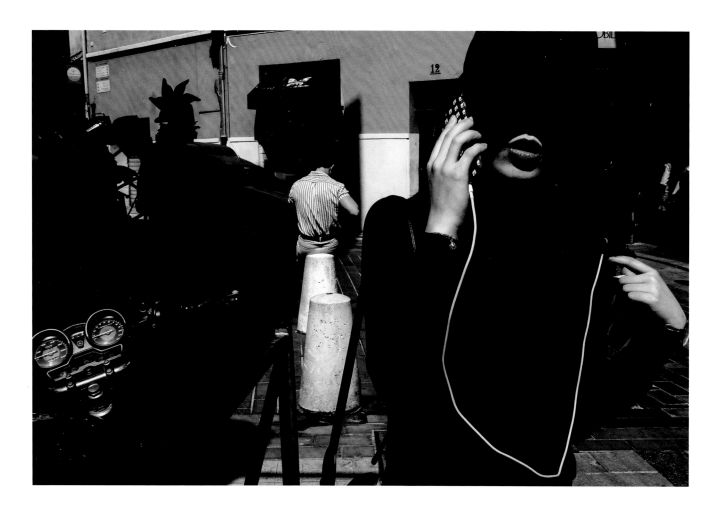

RED LIPS: Walking in old Nice, I notice a scene being built. There is sometimes a certain feeling on the street, something that cannot be described. I observe how people move, and I keep an eye out for interesting colors and light within a frame. Suddenly this girl on her phone turns to me. The curve of her cap creates a shadow on her face, leaving only her red lips in the light. Taking photographs is a mix of feelings: I feel both what I want to capture and the chance that I might succeed.

RUDY BOYER
FRANCE

lensculture.com/rudy-boyer

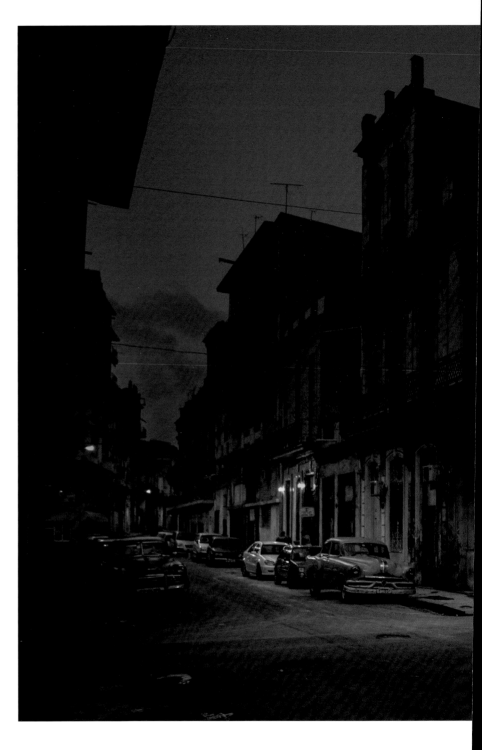

LONELY HAVANA: November 2016, La Havana, right after Fidel Castro's death. Nine days of national grief were announced. Administrations and state services remained closed; the sale of alcohol was forbidden. In these days of grief, it was better to stay at home, mouth shut, with visible sadness. Time is slow in La Havana, especially when you're 25 and dreaming of Miami. Especially when you have no job to do and no money to spend on this island under embargo. Sometimes you drink to forget, but the city ran dry during this "National Grief." So you can't even drink anymore, and the days become longer and longer. Eventually, you find yourself bored to death.

RÉMY SOUBANÈRE
FRANCE

remysoubanere.com

TOKYO STREET / VISION AND FASCINATION:
This city continues to fascinate me. I am invited by its
enchantment: I feel the shutter release. Its visuals are
instantaneous, but by cutting them into a picture, they
become universal and eternal. This work combines
portraits and candid street photographs in a complex
manner, adding to the drama of the city. Sometimes
cruel, sometimes seductive. I catch that moment.

TATSUO SUZUKI
JAPAN

tatsuosuzuki.com

ERNEST FERNÁNDEZ GARRIDO
SPAIN

ernestfernandez.com

I'M NOT A SHADOW, BUT A PUPPET: Taken in Sabadell, an industrial city near Barcelona. As I looked at the graffiti floating on the wall and the people passing underneath, I perfectly understood the artist's intention. My thought was to continue his work with my camera: play with the people's fleeting pace and capture only a glance of them caught like puppets. Blurring together the contemporary, urban world that seems almost dystopian.

SUMMERTIME: Summer is happiness, and happiness is a strange thing that only happens in the past: it is a projection on a mathematically nonexistent point where what we long to have intersects with what we think we have lost. Therefore, returning to summer is impossible. Nevertheless, each year summer insists on coming back. It settles in and displays its deceptive decorations, invites us to close our eyes and try to experience the moment of weightlessness where the temperature is just right, the breeze exact, the effort minimal...

MARÍA SAINZ ARANDIA
SPAIN

mariasainzarandia.com

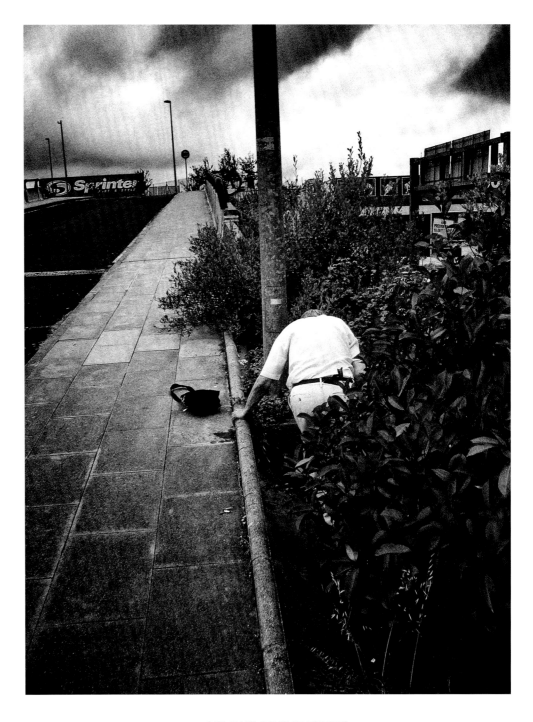

LUIS BOTANA
SPAIN

luisbotana.es

SOLO YO SE QUE EXISTO: In the vital moments, one is always alone. In loneliness, I suffer my suffering, in solitude, I live my joy. Only I know that I exist. We can empathize and share; we can leave the mark of our passage, but ultimately they are just vestiges, mere signs of the life lived. Others will only see what I have left behind: they will not live my existence.

LONELY VERSES: I like to see the city as something alive, a beast that breathes and observes us in silence, that plays with us, creates fantasies of light and shapes that appear and disappear in a fraction of a second. This project talks about how the city, without mediating a word, whispers in our ear the short verses where the meter, the cadence, the lights, and the shadows tell us short stories where we can find ourselves.

SERGIO GARCÍA GAVALDÀ
SPAIN

lensculture.com/sergio-garcia-gavalda

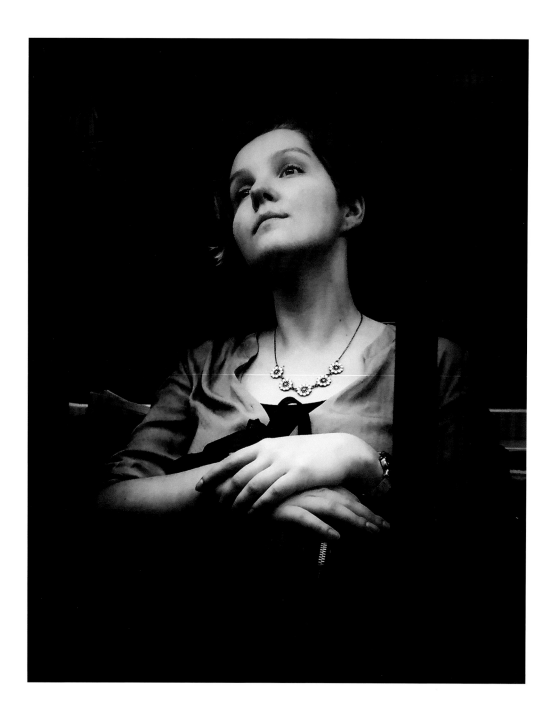

MATT CRABTREE
UNITED KINGDOM

matt-crabtree.com

16TH-CENTURY TUBE PASSENGERS: One morning in 2016, I was sitting amongst a million or so other commuters on my mundane Tube journey into central London, when I looked up to see a lady dressed in a velvet hood, seated in a classical, timeless pose. She was in a beautifully serene world of her own, far away from the noise of it all. Strangely, the London Tube turns out to be the perfect setting for a 16th-century Flemish portrait.

WINTER SOLSTICE: December afternoons in the city center of Oslo, Norway. The days around winter solstice have only a few hours of daylight and the longest nights of the year. Norwegians call this time of the year "mør-ketid"—"the time of darkness." In ancient times, the days surrounding the solstice were called "Yule" and worshipped as a reawakening of nature. The Norwegian translation of "Christmas" is "jul," and many Christmas traditions, such as the Christmas tree, originate from ancient Yule customs.

TINE POPPE
NORWAY

tinepoppe.no

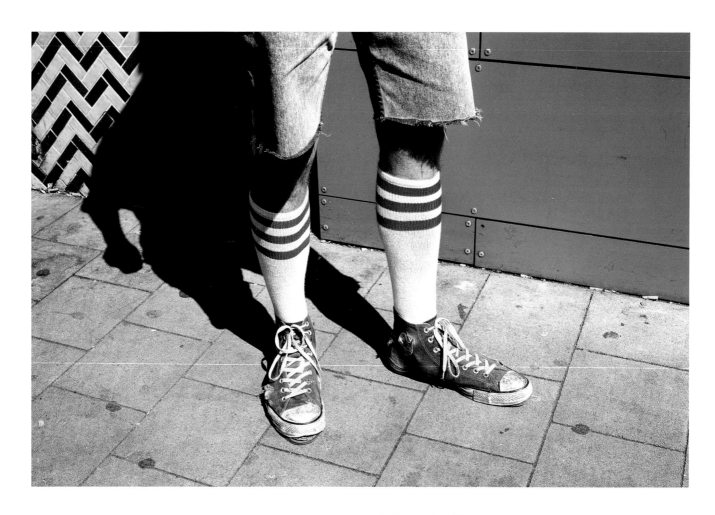

DIAMOND DAYS: The quintessential trait of the mundane is its lack of spectacle. It is recognizable to us in its plainness, its uneventful character. This series is an exploration of that commonplace with a playful touch, a colorful lightness and warmth, a sense of joy. Yet these unassuming landscapes also seem to contain something else. Elusive. Layered. Ambiguous. A somewhat bleaker undercurrent which might pick up on the sensation of slight unease that we often associate with the ordinary.

MANUEL ARMENIS
GERMANY

manuelarmenis.com

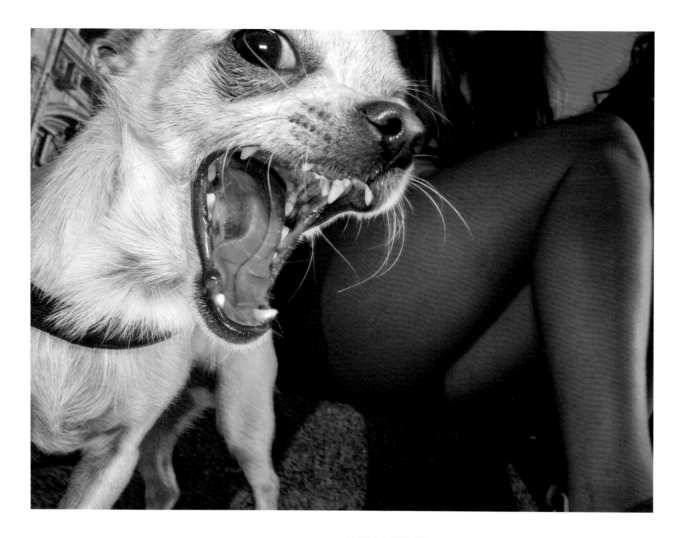

WELL HEELED: Explore the world from a dog's-eye view that us bipeds wouldn't normally see. Behind the coiffed and pampered "children in fur coats," the focus is on their claws, paw pads, incisors, drool-drenched beards, and wet noses. Their canine traits erupt throughout and leave the viewer in no doubt that they are animals who would rather chase rabbits and chew bones than be dressed up with crystal collars, Louis Vuitton leads, and pushed around in prams.

DOUGIE WALLACE
UNITED KINGDOM

dougiewallace.com

GEOMETRY AND COLOR:
Wroclaw, Poland and Kuala Lumpur, Malaysia are two locations which are miles apart both geographically and culturally. In this series, they have been united by a common theme: color and geometry. My vision creates a parallel world where the ordinary and mundane are transformed into the extra-ordinary and ambiguous.

JOLANTA MAZUR
MALAYSIA

jolantamazur.com

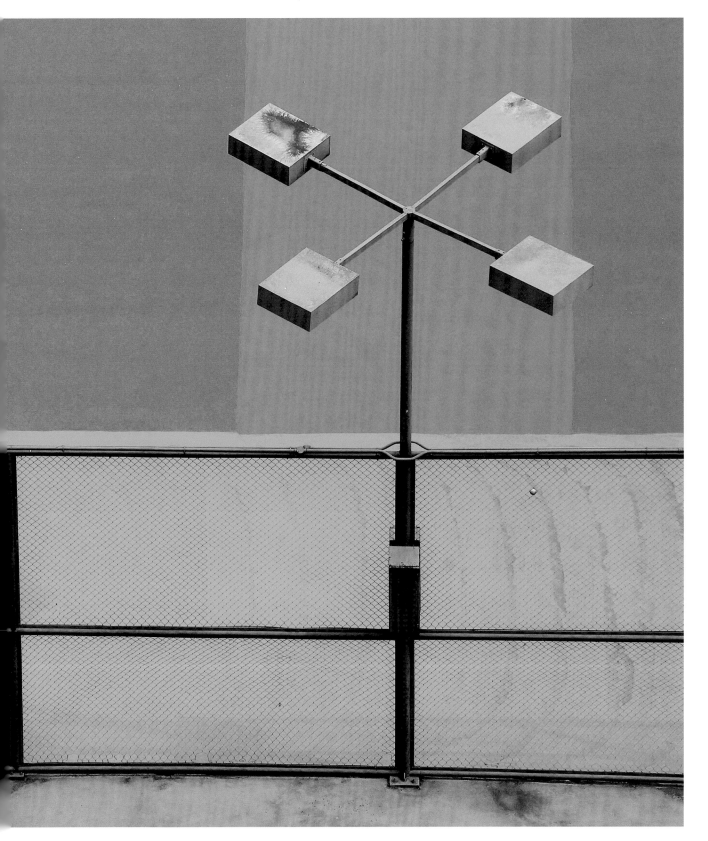

LAVA: Vevian shaves his head by himself. The daily route I take runs through Athens' Omonia Square and the streets nearby. The connection(s) with people, the random incidents, and the unexpected situations are many. In this ever-changing city, different from one day to the next, from each hour to the next, I encounter a constant state of emergency. A volcano ready to explode.

PANOS KEFALOS
GREECE

panoskefalos.com

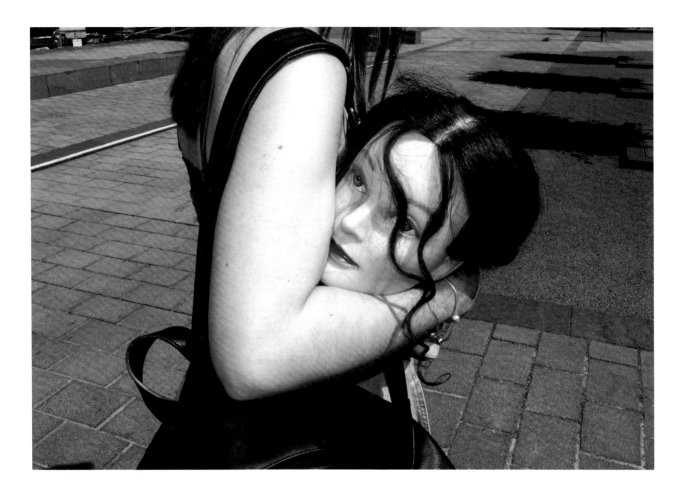

WHILE ALL AROUND ARE LOSING THEIRS: It's the most basic mistake in photographic composition—"Don't cut off their heads!" Visual decapitation...seems like a good idea to me! This candid picture lends itself to many interpretations—is it a metaphor for the 21st century and modern life? Is this image a social comment on extreme cosmetic surgery and mental health—or just a beautifully observed slice of everyday life?

DAVID BARRETT
UNITED KINGDOM

ukstreet.photography

EXHAUSTED NYC: FAMILIES: The allure of New York's subways has always been intrinsic to my street photography. For my subway series, I prefer to work covertly and quickly—I shoot what catches my eye, but it's my response to the mise-en-scène that's most critical: a mother in deep repose still protectively clutches her daughter's arm, or two lovers uneasily spoon, on the jittery edge of wakefulness. Napping on a subway is a dangerous luxury; to do so involves trust in humanity. It's a poignant and powerful moment of extreme vulnerability, and that is what I'm trying to capture.

CYNDI GORETSKI
UNITED STATES

lensculture.com/cyndi-goretski

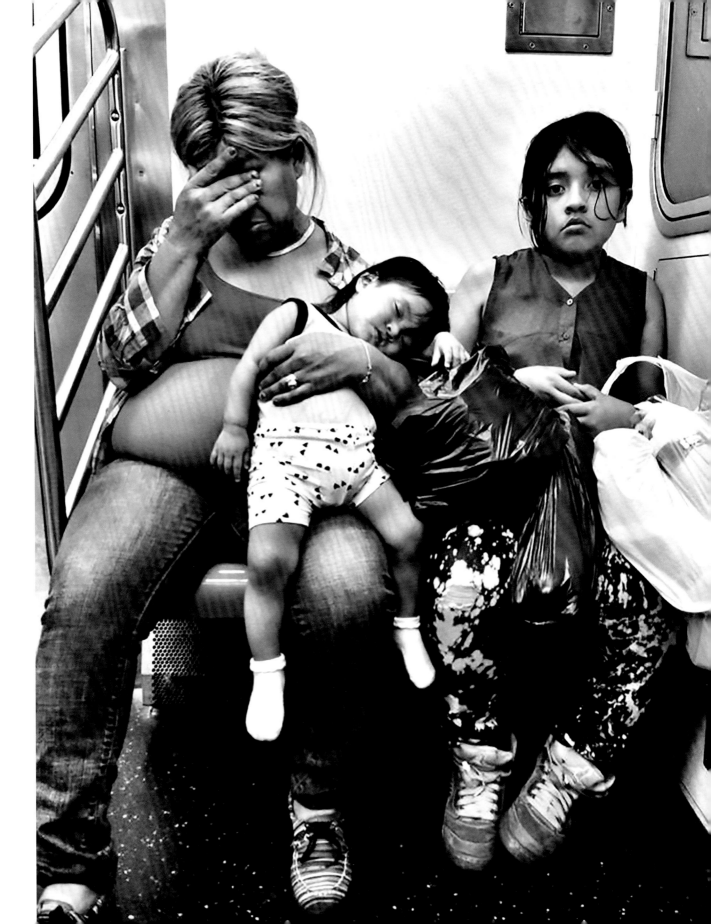

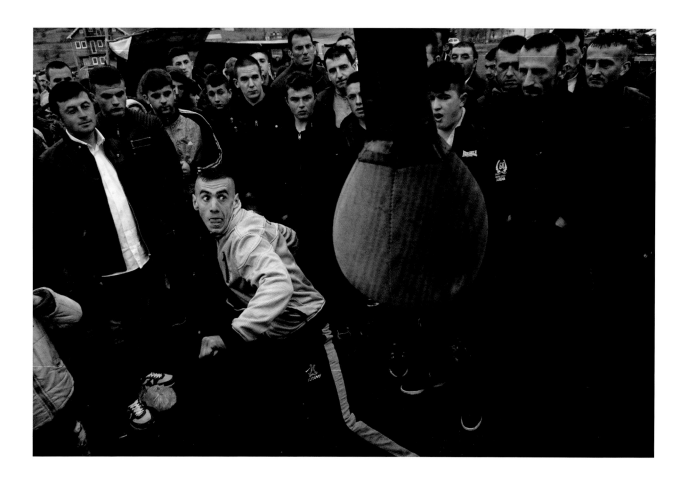

HIT: I made this image in a Serbian village called Delimeđe. The scene took place during an event that occurs every year, where the local people organize various activities and spend time together.

IRFAN LICINA
SERBIA

lensculture.com/irfanlicina

BEYOND STREET: A couple of lads show off their muscles just before a wrestling match. My photographs represent my own personal experience and space within which I communicate and create a dialogue with unknown strangers whom I meet accidentally on the street. Yet somehow, unintentionally, I build a strong bond with them. As long as I capture strong subjects with varied emotions that people can easily relate to, I have done justice to myself.

SWARAT GHOSH
INDIA

swaratg.wordpress.com

CLOSING DEAL: A top-down view of a poultry seller closing a deal with a customer at the busy Chow Kit Market in Kuala Lumpur, Malaysia.

JOSEPH CHEUNG
MALAYSIA

lensculture.com/joseph-cheung

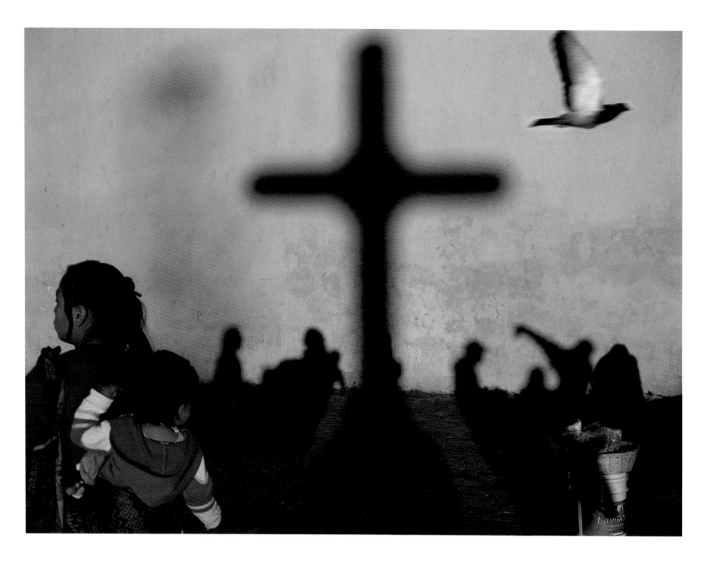

MEXIQUE, 2017: San Cristóbal de las Casas, Mexico.
In the absence of a body, the presence of its projection,
the shadow, catches our eye. Objects and people try to
cut a path through the black of repression towards its
release—the light.

HÉLÈNE ANTORINI
SWITZERLAND

hdecuyper.com

HEAVEN'S GATE: By overexposing these images, the shop windows I depict are transformed into light boxes without further meaning. They illuminate the street and occupy completely the brains of the passersby. This is my direct critique of consumerism and capitalism: the architecture recalls sacred buildings, leading us back to the ironic title of the series.

LINUS KNAPPE
GERMANY

linus-knappe.de

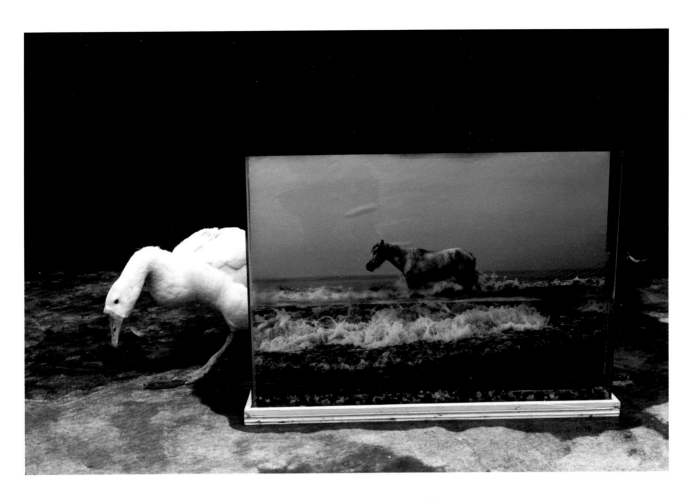

COEXISTENCE: In every society, old and new, people have coexisted with animals, and will continue to do so. Our interaction with animals happens in varying ways, from practical necessity to emotional needs. Living surrounded by animals teaches humans humility, honesty, and sensitivity. There is no way to fool animals. One has to behave right to get an animal's respect. Getting closer and closer to the stray animals of a city made me feel more compassionate.

MD ENAMUL KABIR
BANGLADESH

flickr.com/photos/enamul_kabir_rony

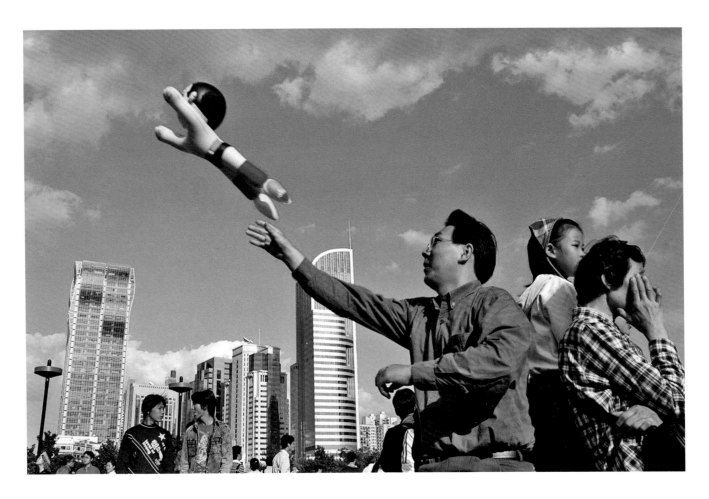

CHILDLIKE INNOCENCE: People's Square, Shanghai, a place for holiday-makers and visitors to enjoy the city's leisure activities. Here, a man plays with a child's plastic toy.

SHENGHUA FAN
CHINA

lensculture.com/shenghua-fan

EXPOSURE
AWARDS

"Sites such as LensCulture,
which offer new perspectives
on the world via a wide range of
photographs, are an important
means of combating the
isolationism that is profoundly
impacting our lives these days."

Mazie Harris, Assistant Curator of the Department
of Photographs, Getty Museum

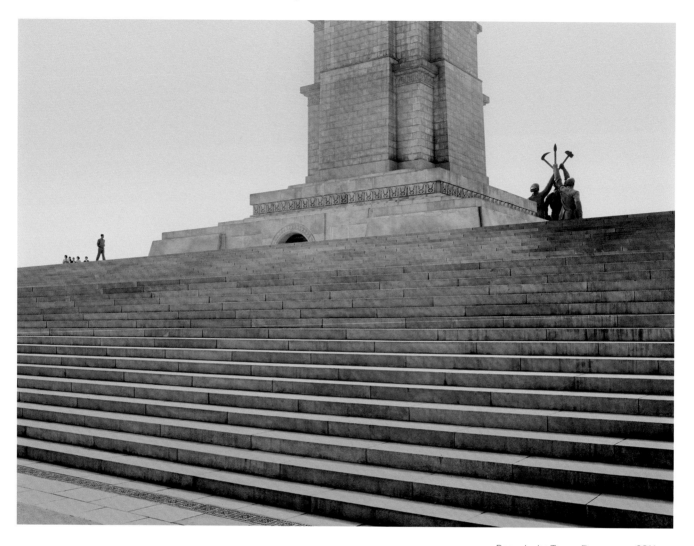

Base, Juche Tower. Pyongyang, 2014.

EDDO HARTMANN
THE NETHERLANDS

eddohartmann.nl

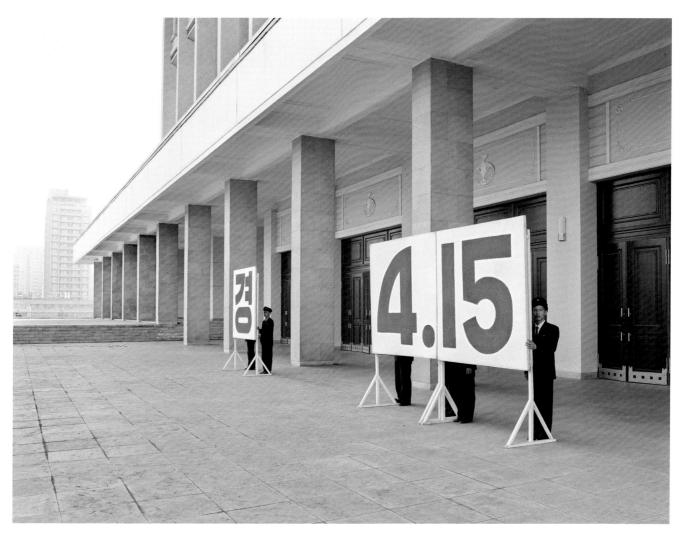

Day of the Sun. Celebrations on the birthday of the Eternal Leader Kim Il-sung. April 15, 2014.

SETTING THE STAGE | NORTH KOREA

After the total destruction of North Korea's capital, Pyong-yang, during the Korean War (1950-1953), the government seized the opportunity to rebuild the city from the ground up. Having made four trips there over the last few years, I created this project to portray the North Korean regime's ambition to construct the ultimate socialist city while completely shaping the lives of its inhabitants after this ideal model.

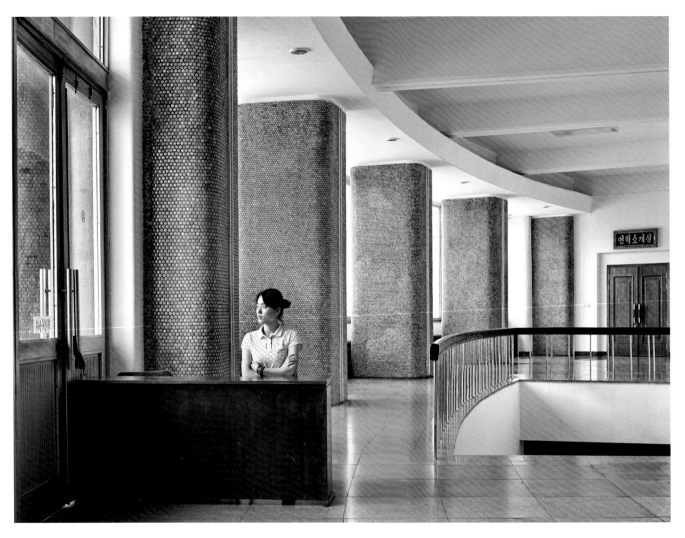

Entrance to the ice rink. Pyongyang, 2016.

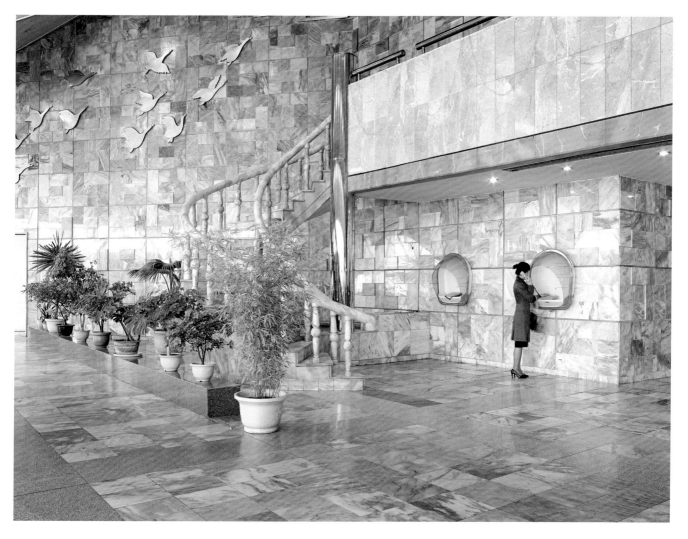

Lobby of the Yanggakdo hotel. Pyongyang, 2014.

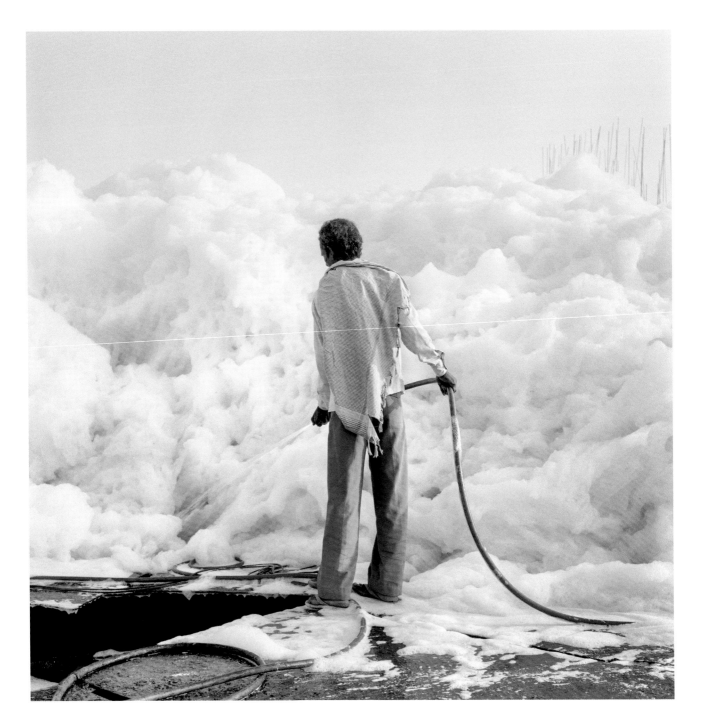

GIULIO DI STURCO
UNITED KINGDOM

giuliodisturco.com

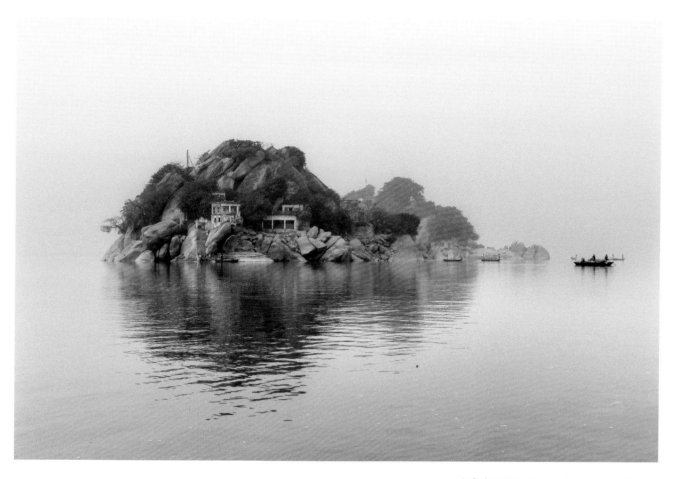

Left: A worker with a water hose tries to tame an iceberg of foam formed from chemical waste. Above: The Ganges River.

LIVING ENTITY

The Ganges River is a symbol of Indian civilization and spirituality—it is a source of poetry and legend that is older than Athens or Jerusalem. For centuries, people have journeyed here to find the heart of Hindu culture in India. As part of the preservation and renewal of ancestral traditions, food, flowers, and other religious offerings are set afloat across its waters every day. But now, the Ganges is on the brink of an ecological crisis.

Throughout the course of this project, I traveled the entire length of the Ganges. For more than eight years, I documented the lives of the people who live along the river, witnessing firsthand the devastating effects of climate change, industrialization, and urbanization. In Hindu mythology, the Ganges is considered a "Tirtha," which means a crossing point between heaven and earth. My fear is that this bridge may crumble in our lifetime.

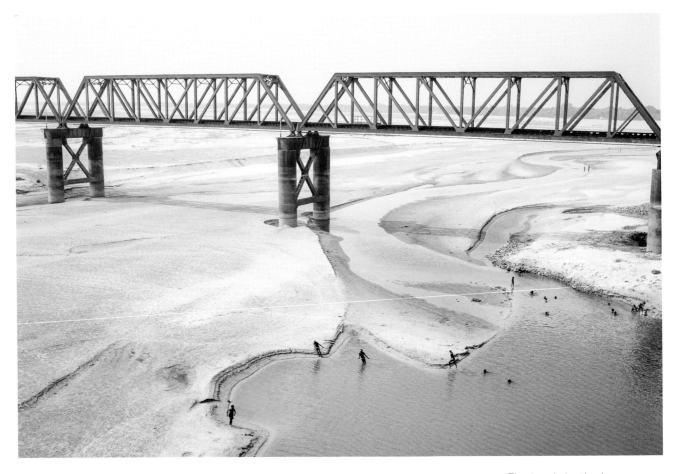

The river during the dry season.

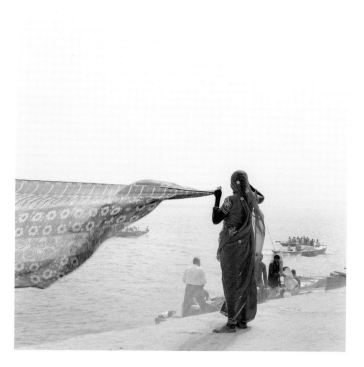

Devout Hindus perform the sacred
ablutions in the waters of Varanasi.

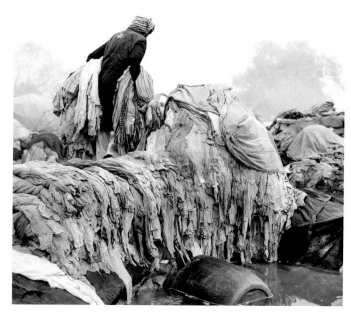

A makeshift laundry.

FATEMEH BAIGMORADI
UNITED STATES

fatemehbaigmoradi.com

IT'S HARD TO KILL

My parents have only a few photos of themselves from before
the Iranian Revolution in 1979. A few years before the regime
change, to avoid risk of arrest, my father burned any visual
evidence that referenced his membership to the opposing
political party. My obsession with these photos, and with the
photos we do not have, led me to create this work.

Fatemeh Baigmoradi - United States - 231

CÉSAR DEZFULI
SPAIN

cesardezfuli.com

AMADOU SUMAILA

Amadou Sumaila, 16, from Mali, poses for a portrait minutes after being rescued on the Mediterranean Sea, 20 nautical miles off the Libyan coast, by a rescue vessel provided by the NGO Jugend Rettet. The rubber boat in which he traveled carried 118 people on board, who were then transferred by the Italian Coast Guard to Lampedusa, Italy. The portrait was made on August 1, 2016.

Amadou is currently living in a temporary reception center for migrants in Sicily, where he is still waiting for an answer to his asylum request.

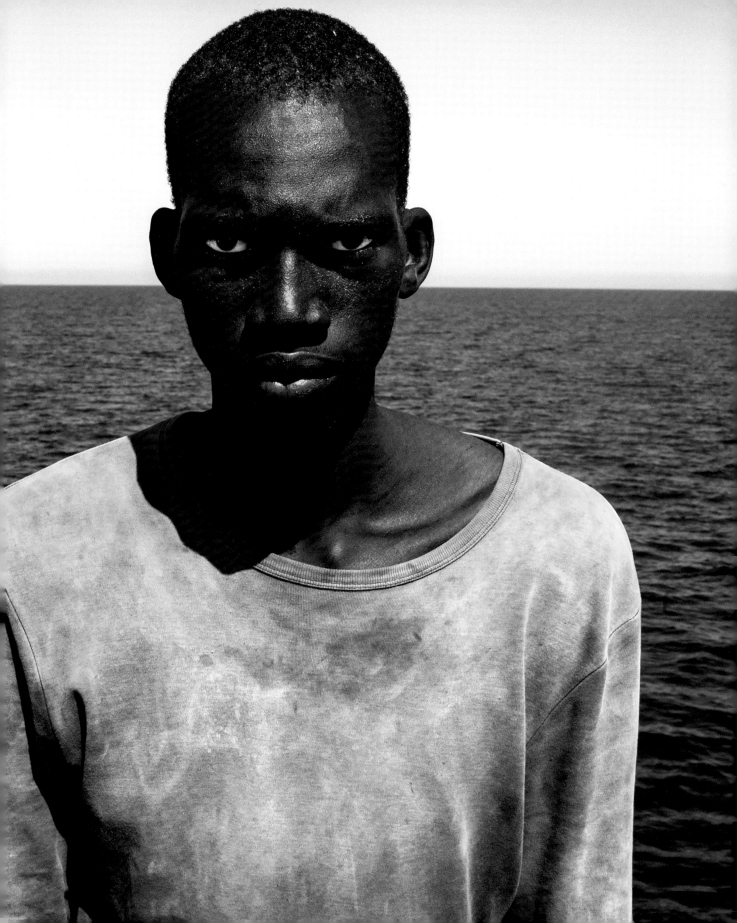

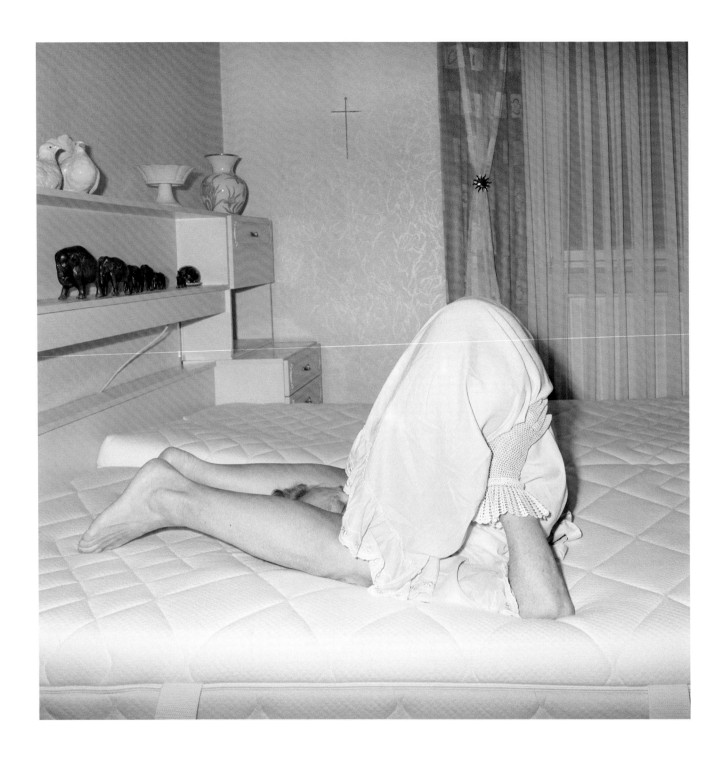

NINA RÖDER
GERMANY

ninaroeder.de

MUM IN BED

After my grandparents died last year, we had to sell the
house where both of them had lived for more than 60 years.
 This picture was taken in their house while we tried to
clean and empty everything. Specifically, I made this in the
bedroom with my mum in a yoga pose. The only way for us to
not be too sad about losing this house, with all its memories,
was to do absurd things.

ANTHONY ASCER APARICIO
VENEZUELA

lensculture.com/anthony-ascer-
aparicio

THE ARREST OF LUIS THEIS

Luis Theis is a young artist who was arrested on May 18, 2016 during a protest against Nicolas Maduro's government. After a week of intense legal battles against the judicial and penitentiary system, Luis Theis achieved his freedom on May 26.

Theis has become a poster child for the Venezuelan youth of this era: rebellious, harassed, apprehended, tortured, and killed just for thinking differently; just for demanding and exercising his constitutional rights.

Hand in Water.

BASTIAAN WOUDT
THE NETHERLANDS

bastiaanwoudt.com

Girl.

MUKONO

I was asked to join a field trip to Mukono, Uganda in order to document a clean drinking water project undertaken by the Marie-Stella-Maris Foundation. The people, the land-scapes, the still lifes, and the stories—it was mesmerizing.

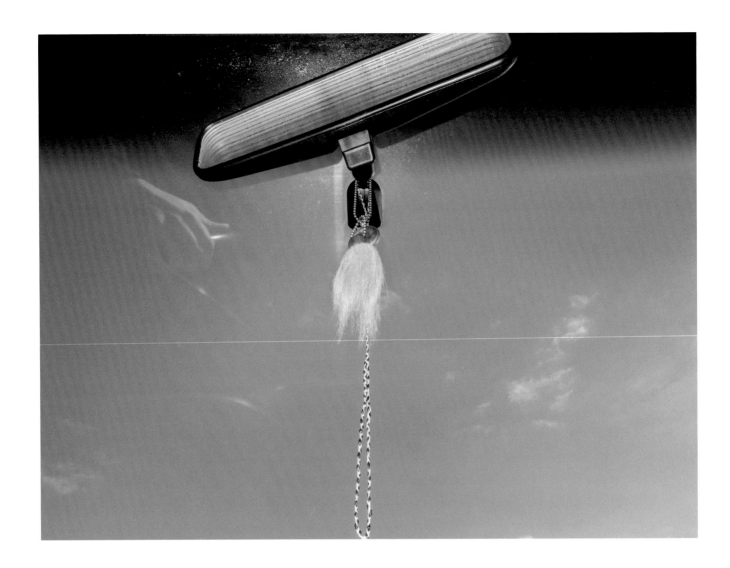

M L CASTEEL
UNITED STATES

mlcasteel.com

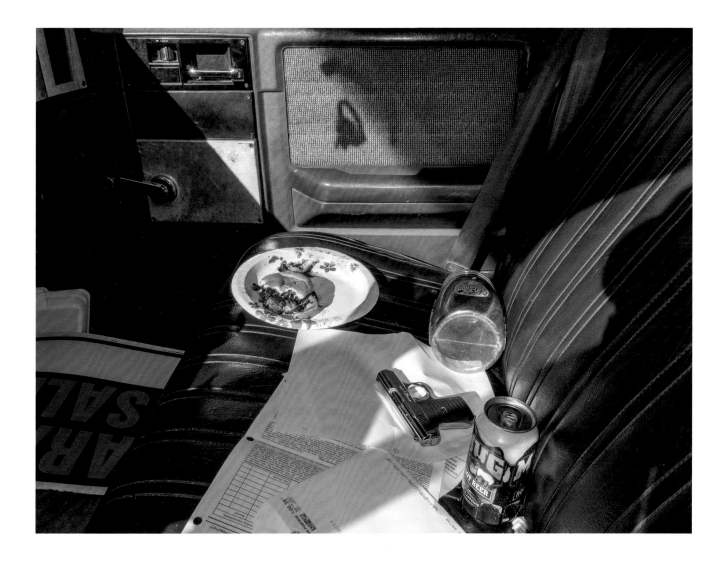

AMERICAN INTERIORS

It is generally recognized that the condition of one's dwelling can often be a signifier for one's state of well-being. I see the state of these car interiors as manifestations of human interiors. This project depicts the psychological repercussions of war and military service through images of the interiors of cars owned by United States veterans.

 The work is my attempt to bridge a deep sense of rebellion and outrage towards institutionalized violence (via warfare and the American military-industrial complex) with the empathy and sadness I hold for the people who have survived the military experience. The convening "portrait" is not a pretty picture, but is an accurate representation of what I see and feel regarding the plight of the American veteran.

Mr. Fujio Torikoshi, 86. "Life is a curious treasure."

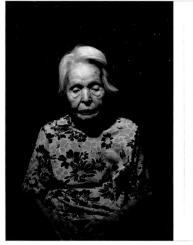

Ms. Kumiko Arakawa, 92.

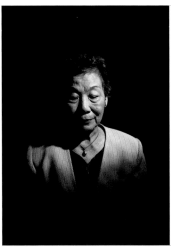

Michiko Yagi, 78. "The site of the bombing is now a pristine park. Back then, however, it was a bustling town where many people lived and worked. A single atomic bomb destroyed everything underneath it. Humans cause war. Thus, only humans can prevent it. Peace is not something that we passively wait for. Peace is something that we must cultivate. Dear reader, please make Nagasaki the last A-bomb site." (abridged)

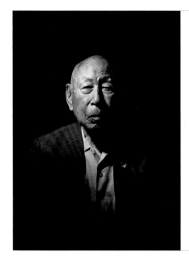
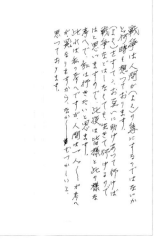

Mr. Masakatsu Obata, 99. "I often think that humans go into war to satisfy their greed. If we rid ourselves of greed and help each other instead, I believe that we will be able to coexist without war. I hope to live on with everyone else, informed by this logic. This is just a thought of mine—each person has differing thoughts and ideologies, which is what makes things challenging."

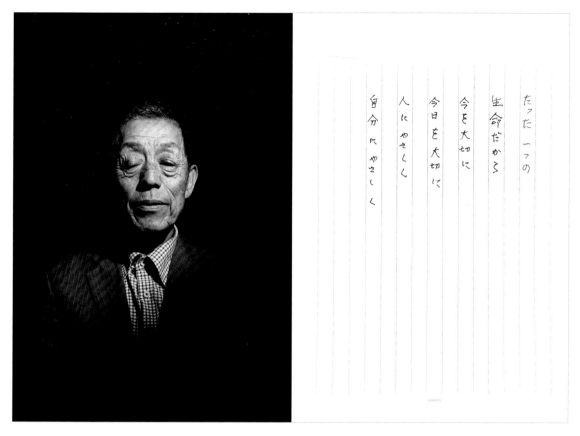

たった一つの
生命だから
今を大切に
今日を大切に
人にやさしく
自分にやさしく

Yasujiro Tanaka, 75. "You are only given / One life / So cherish this moment / Cherish this day / Be kind to others / Be kind to yourself."

HARUKA SAKAGUCHI
UNITED STATES

1945project.com

1945

These images are part of an ongoing portrait series of hibakusha, or victims of the U.S. atomic bomb attacks in Hiroshima and Nagasaki. As first-generation hibakusha grow older, it has become increasingly difficult to collect firsthand accounts of the atomic bombing and to truly understand the human costs of nuclear warfare.

These subjects were asked to participate in hour-long interviews to provide their testimonies and to prepare a letter for future generations, which is placed next to their portrait.

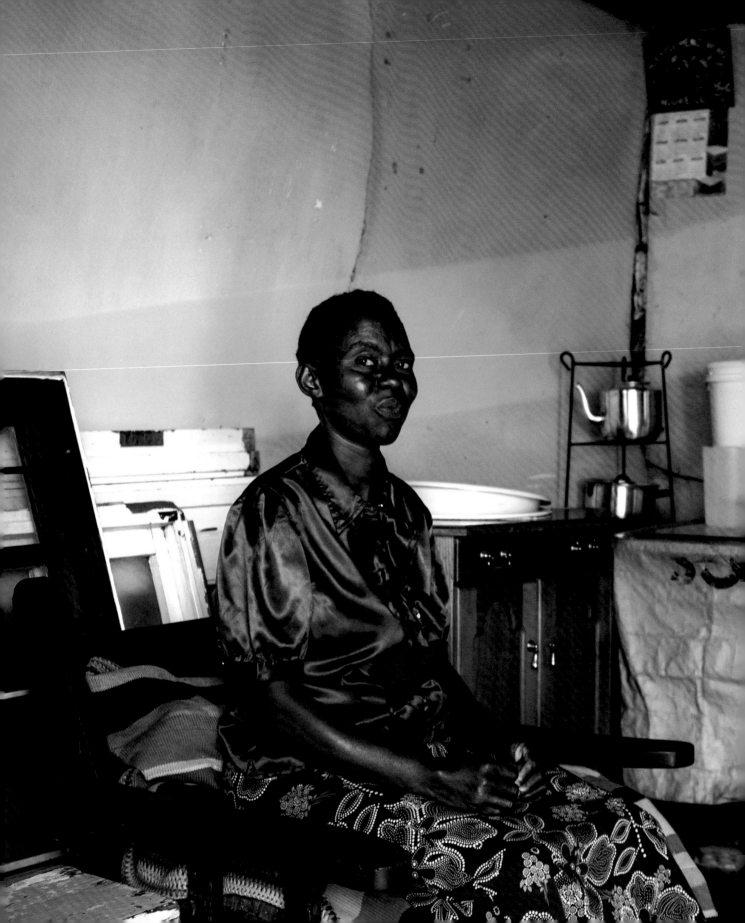

CHRIS KIRBY
UNITED KINGDOM

chris-kirby.co.uk

WE GAVE YOU FORGIVENESS...

Two decades after Nelson Mandela was elected, and after the much-lauded peace and reconciliation process, racial tension in South Africa is still a major issue. Many believe that the country has become more divided as the economy has failed to deliver the growth and jobs promised that would bring greater financial equality to the population as a whole.

For the majority of South Africans, not much has changed economically in the past twenty years. I wanted to reflect this using visual aesthetics.

In my work, I often embellish my images with lines, marks, and coloring to disrupt the conventional perspective associated with the medium and the subject matter. In a nuanced way, I hope this conveys deeper meaning to the imagery.

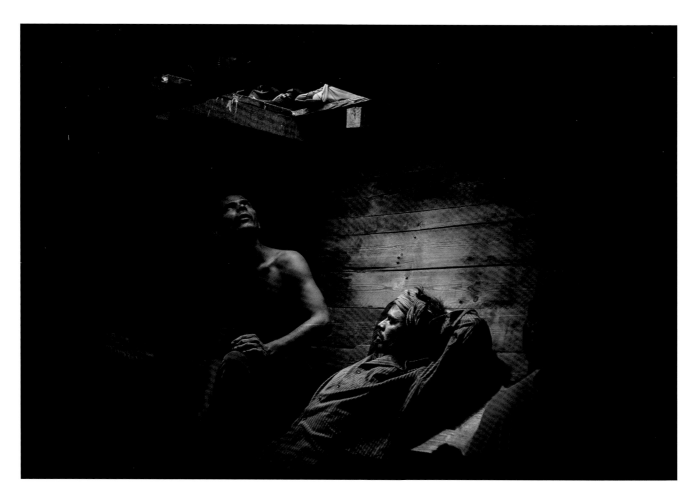

414 migrants and refugees were found
lost at sea off the coast of Libya.

JASON FLORIO
UNITED KINGDOM

floriophoto.com

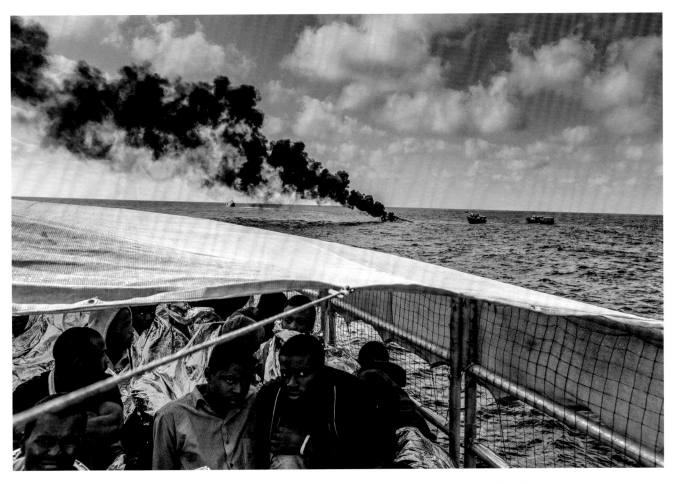

Gambian and other West African migrants just rescued from a packed rubber boat off the coast of Libya huddle on the deck of Migrant Offshore Aid Station's ship.

DESTINATION EUROPE

For two years (2015-16), I was embedded with the first search and rescue NGO, Migrant Offshore Aid Station, to operate rescue ships. Their specific aim is to save the lives of migrants and refugees attempting to cross the Mediterranean and Aegean Seas. My initial embed was for three weeks, but I was soon emotionally invested in the story, and I stayed on to make multiple sea missions over the next two years. I am now focusing my work on the effects of mass migration in source countries including The Gambia and other host countries.

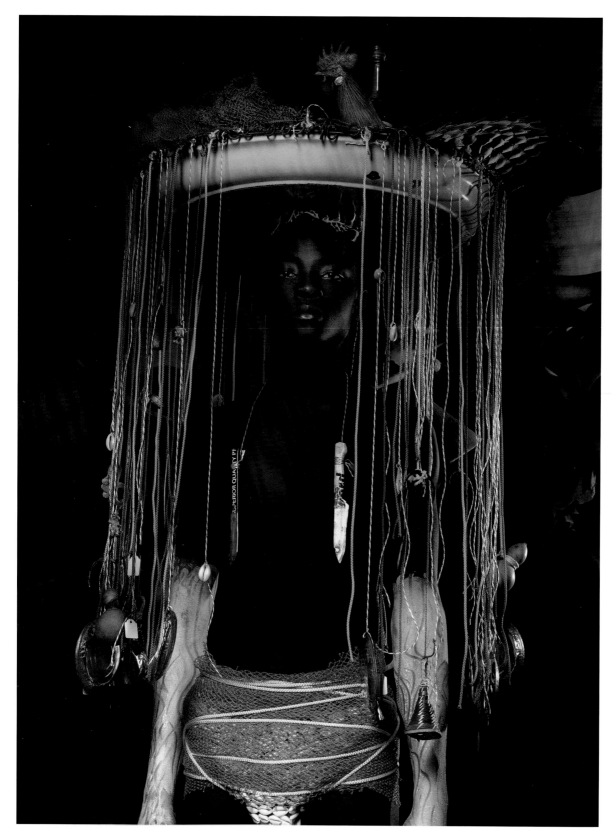

Azaca.

namsaleuba.com

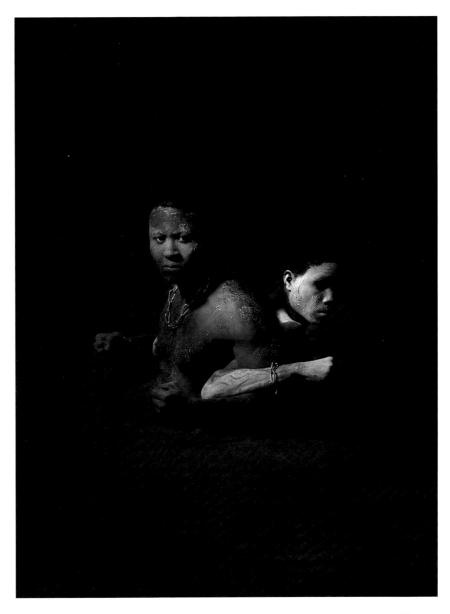

Olou.

WEKE

Benin is the birthplace of vodun (voodoo), a practice that
predates many other religions by thousands of years. My
photographs are inspired by these local animist traditions
that stipulate the continuity of all things, both visible and
invisible, in the universe. Using graphic elements inspired
by paintings, I revisit the symbols of this ancestral belief
from a contemporary, Westernized perspective.

Water to Wine.

DYLAN HAUSTHOR
UNITED STATES

dylanhausthor.com

WILTING

Within this project lie stories buried beneath the snow and the mud. The humans and animals that live here wander the threshold between an unapologetic existence and an abyss of lunacy. These stories are written and performed by a mind under house-arrest. This results in a land both ancient and false, co-authored by artist and subject.

Shedding.

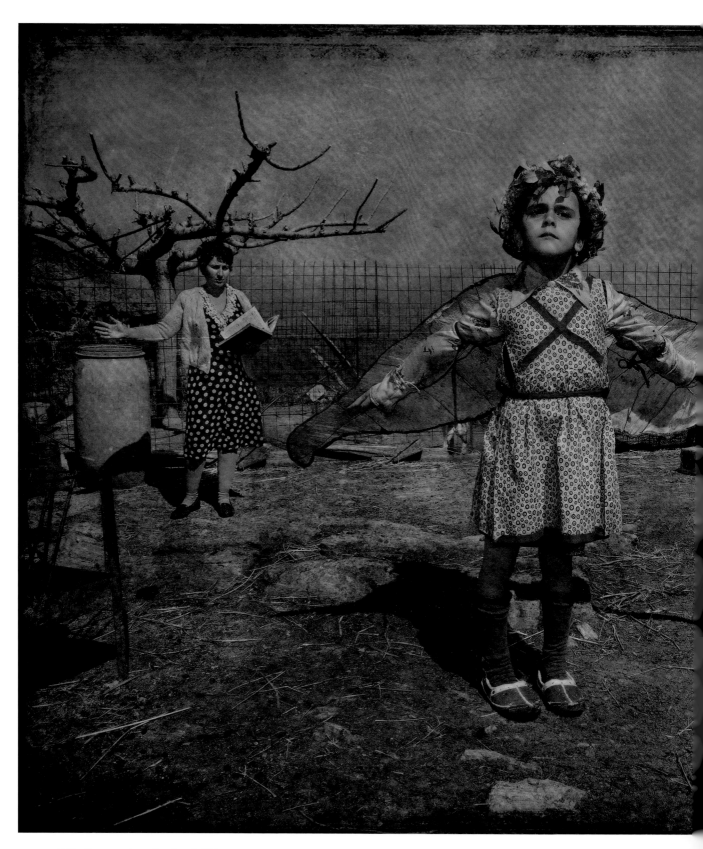

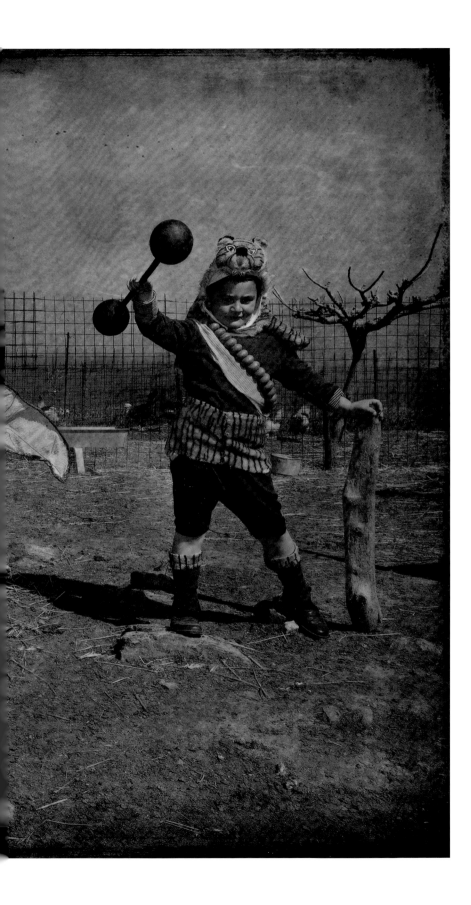

DAPHNE ROCOU
GREECE

lensculture.com/daphne-rocou

PARADISI REGAINED

Hercules and Glory. The setting for this photo story is the remote village of Paradisi, in south Evia, Greece. It takes place in the 1950s but it might have happened in any part of the world, at any time; it is a project about the loss of real knowledge and education. A young teacher, remembered as Miss Antigone (thanks to her favorite play, "Antigone" by Sophocles), inspires a new spark of life in her students through her teaching.

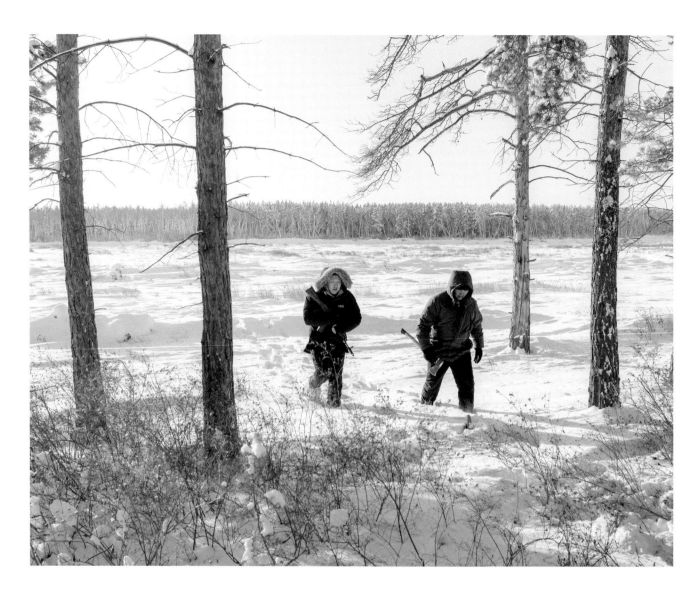

A REINDEER AND A BURNING OIL CAN: Uniting fictive scenarios with those created under "documentary" circumstances, this series was photographed in Yakutsk, in the far east of Russia—the coldest city in the world. In my images, I playfully utilize clichés while searching for the traces of fiction and alleged reality that lie at the borders of authenticity and documentary photography.

JAKOB SCHNETZ
GERMANY

jakobschnetz.com

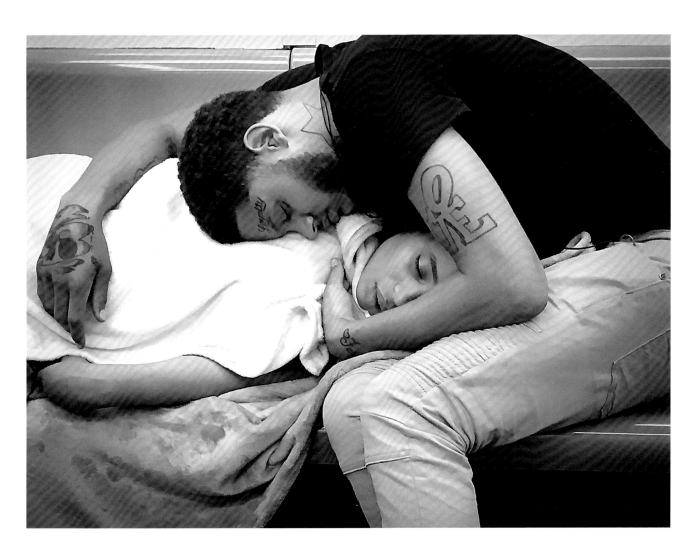

LOYALTY & LOVE: Retreating from crowded sidewalks to the dank intimacy of New York's public transit system, heading home to East Harlem, I escape the city's unforgiving pace—and notice others doing the same. Napping on a subway is a poignant and powerful moment of extreme vulnerability, and that is what I'm trying to capture.

CYNDI GORETSKI
UNITED STATES

lensculture.com/cyndi-goretski

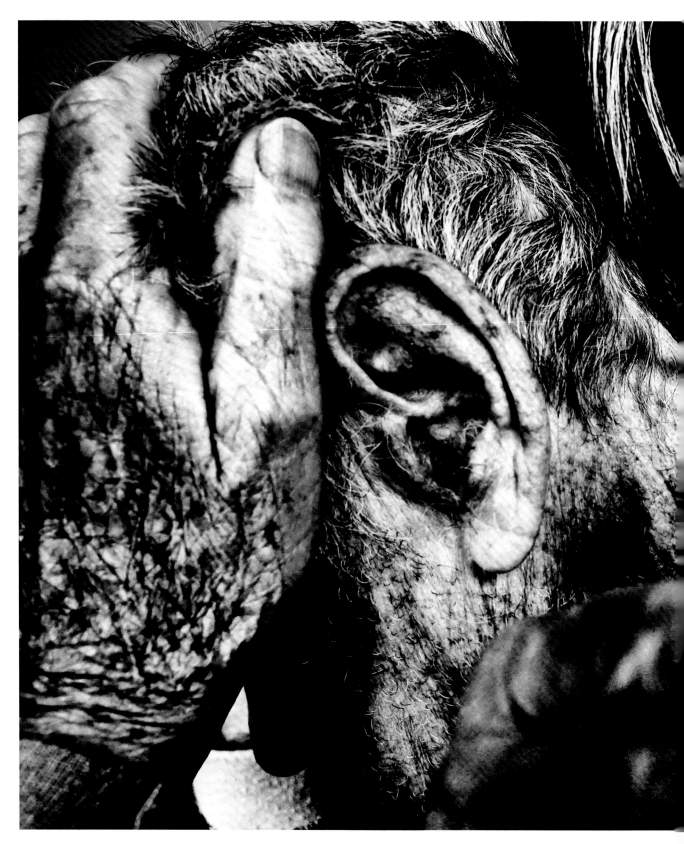

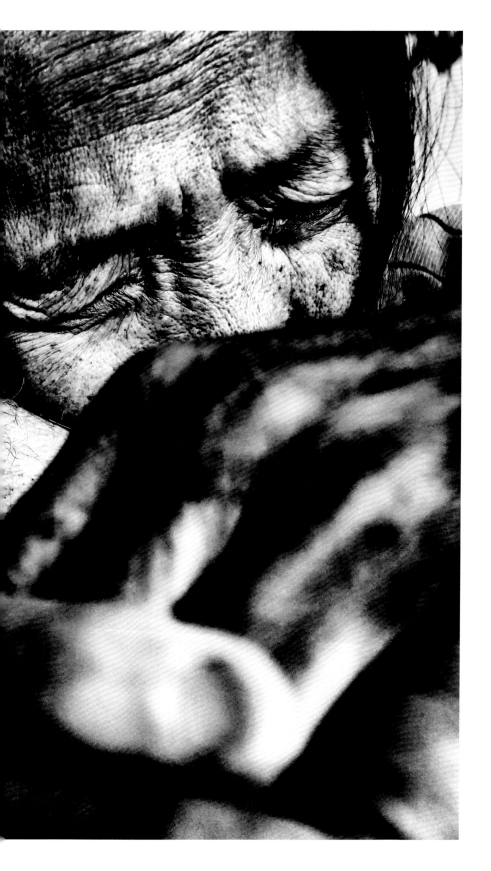

THIS, OUR STAGE FOUR: In a
desperate tone, my mother told me
that my father had suddenly been
hospitalized: it was pancreatic
cancer. Trying to make sense of the
situation, I immediately began
making a record with my camera.
The resulting document is one of
vision and voice, bound together
through a personal process of grief.
I hope these images create an
emotional map, one that reveals our
connectedness to each other while
also furthering an understanding
for all those navigating the loss of
a loved one.

ARGUS PAUL ESTABROOK
SOUTH KOREA

arguspaul.com

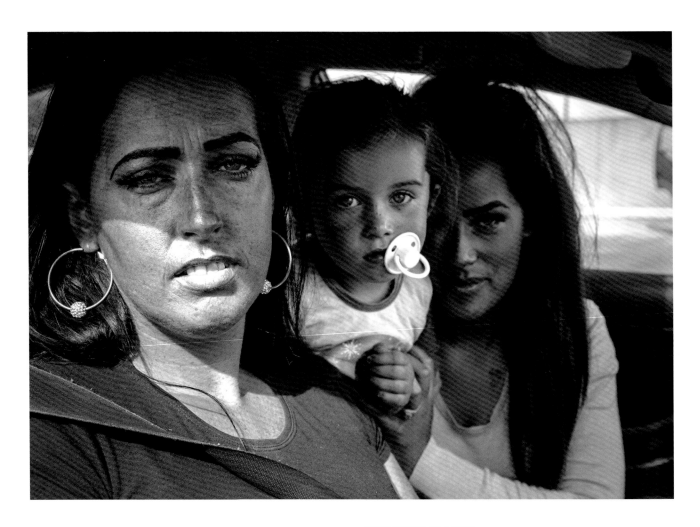

IRISH TRAVELLERS: A proud and reclusive people, the Travelers maintain a culture and set of traditions whose origins are lost in time. Here, I reflect on my personal interactions with a group I was fortunate to connect with at the Ballinasloe Horse Fair, various halting sites, and illegal encampments throughout County Galway in the west of Ireland.

REBECCA MOSEMAN
UNITED STATES

mosemanstudios.com

APORIA: Photographs that speak to the phenomenon of rapid growth being experienced in many urban locations around the world. When surrounded by such an environment, the cultural and physical landscape feels stretched to its limits.

ANDREW WAITS
UNITED STATES

andrewwaits.com

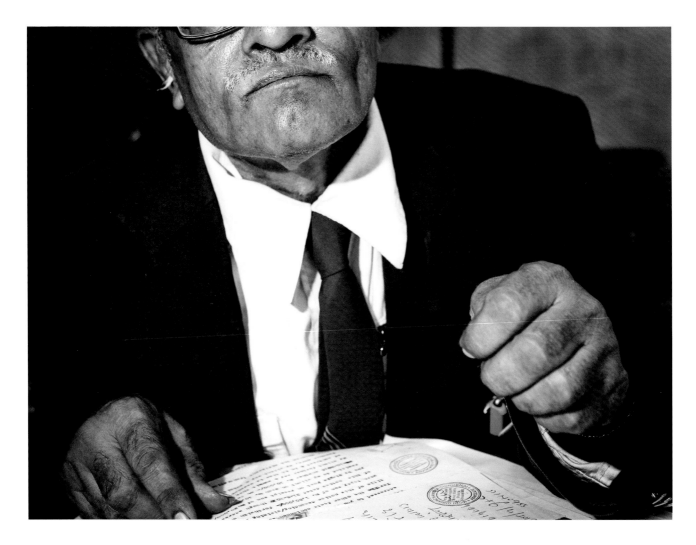

HELP DESK: RANDOM ACTS OF ADMINISTRATION:
Someone from India once told me, "In India, every 40 kilometers everything changes: the food, the language, the mentality. The only constant is the conditions in the governmental offices." I wanted to review this thesis. Here, unofficial lawyers in front of Indian courts offer legal advice in exchange for money. City Civil Court, Ahmedabad.

OLE WITT
GERMANY

ole-witt.de

FATA MORGANA: The Fata Morgana, a mirage, is visible from my region, Salento, in the southern part of Italy. Salento, like all of Europe, has recently become a false place of wonder and hope for the people who are fleeing their homes in search of a better life. These pictures represent a metaphor for our geopolitical situation, which quickly transforms reality into myth and myth into reality.

ALESSIA ROLLO
ITALY

alessiarollo.com

OFFERINGS: "At which point does God become part of our daily lives?" Every place has their own tradition or set of traditions. Although we humans created these traditions, there is something beyond human—immortal—about it. In this work, I focused on the subject of "rituals" and I photographed related objects and situations.

KENTA NAKAMURA
JAPAN

kentanakamura.com

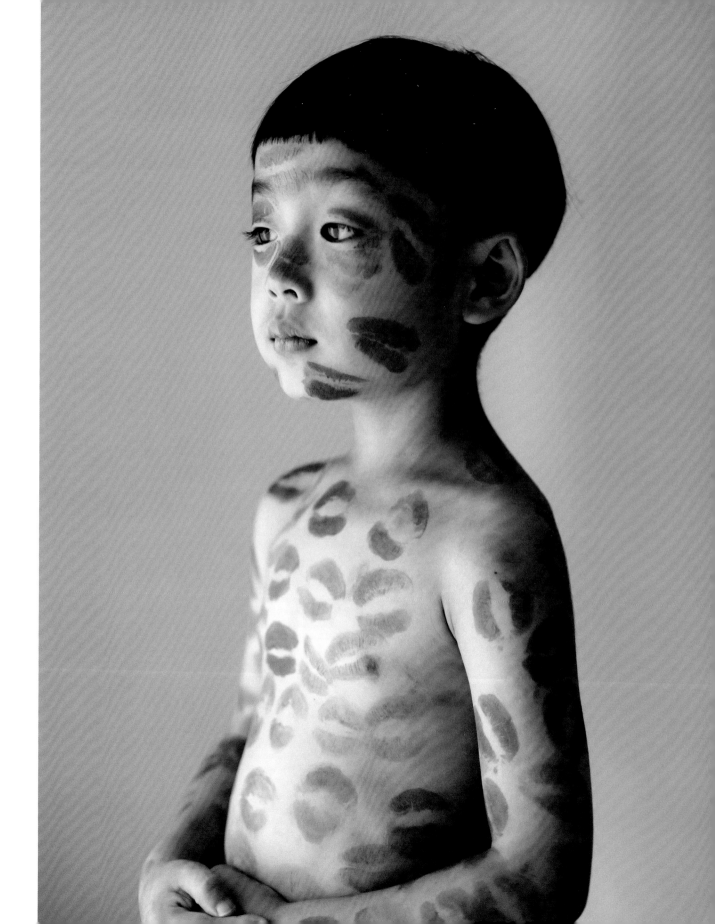

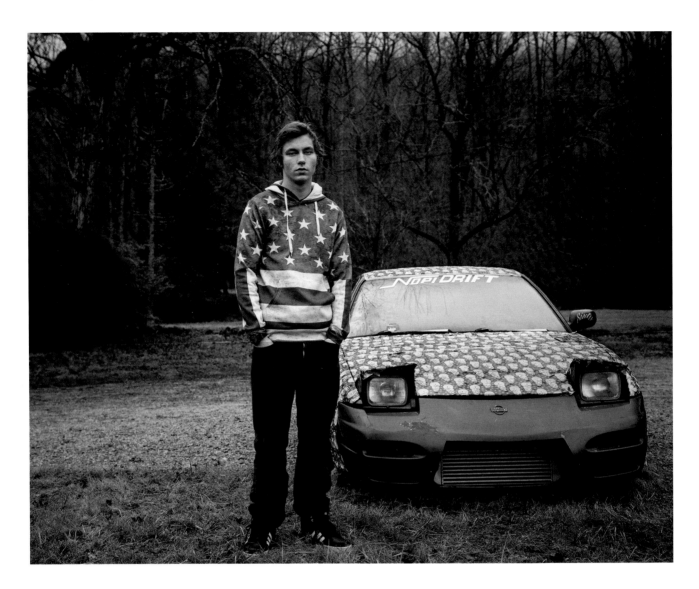

RABUN, GEORGIA: Boy with gift-wrapped car. Situated amongst the Blue Ridge Mountains in Appalachia, Rabun is steeped in cultural specifics associated with both the Deep South and Appalachia. It is a place with a long memory, populated by families that often trace their lineage to the founding of America.

JENNIFER GARZA-CUEN
UNITED STATES

garza-cuen.com

IF I COULD ONLY REMEMBER: This is the Matterhorn, a well-known symbol of Switzerland. This photo represents me looking at my dreams from far away. In my mind, Switzerland has always been like a dream I'm trying to reach.

MACIEJ CZEPIEL
SWITZERLAND

maciejczepiel.ch

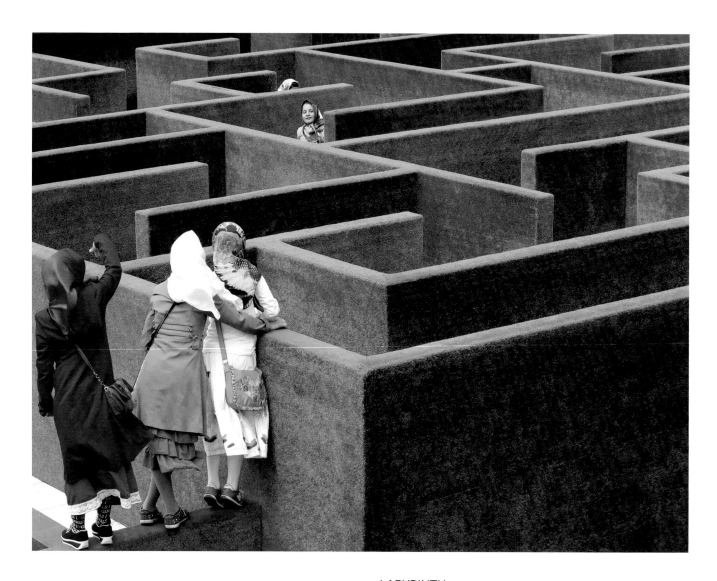

LABYRINTH: This photo was taken in Miniatürk, Istanbul—a theme park that contains replicas of all of the treasures found in Turkey.

ALI BILGE AKKAYA
TURKEY

alibilgeakkaya.com

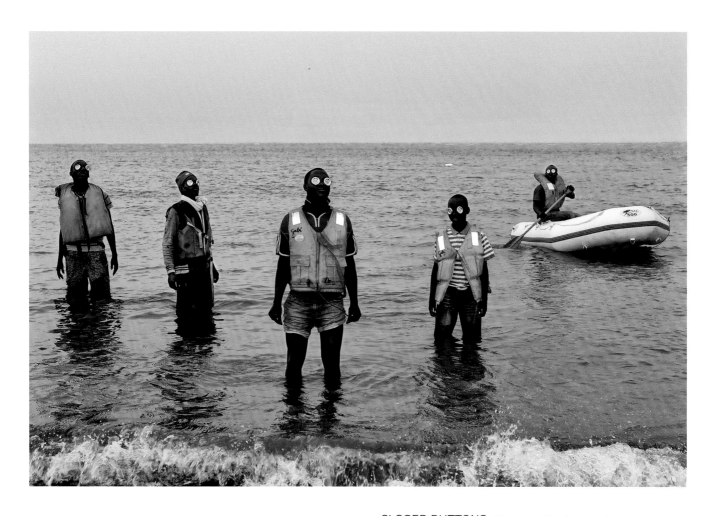

CLOSED BUTTONS: Many people close their eyes to the problems of the world, like buttons. In my image, I used buttons to cover the eyes of my subjects. This photo refers to a current event in the world—maybe it will open your eyes.

KARS TUINDER
THE NETHERLANDS

ktf.nl

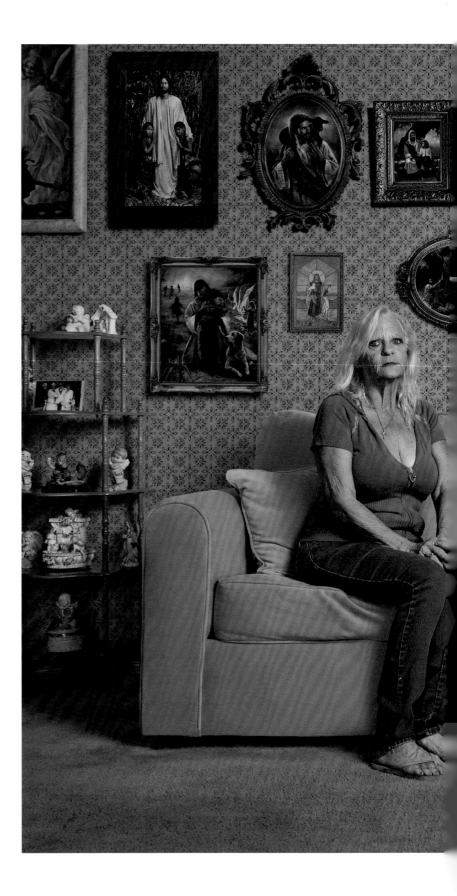

CRAIGSLIST ENCOUNTERS: The family that prays together...A series of portraits of people I found on Craigslist using this ad: "Portrait subject needed (Anywhere). Compensation: $20 per hour. Looking for interesting people to photograph...all shapes, races, genders, and sizes are welcome. I will come to you at your convenience."

KREMER JOHNSON
UNITED STATES

kremerjohnson.com

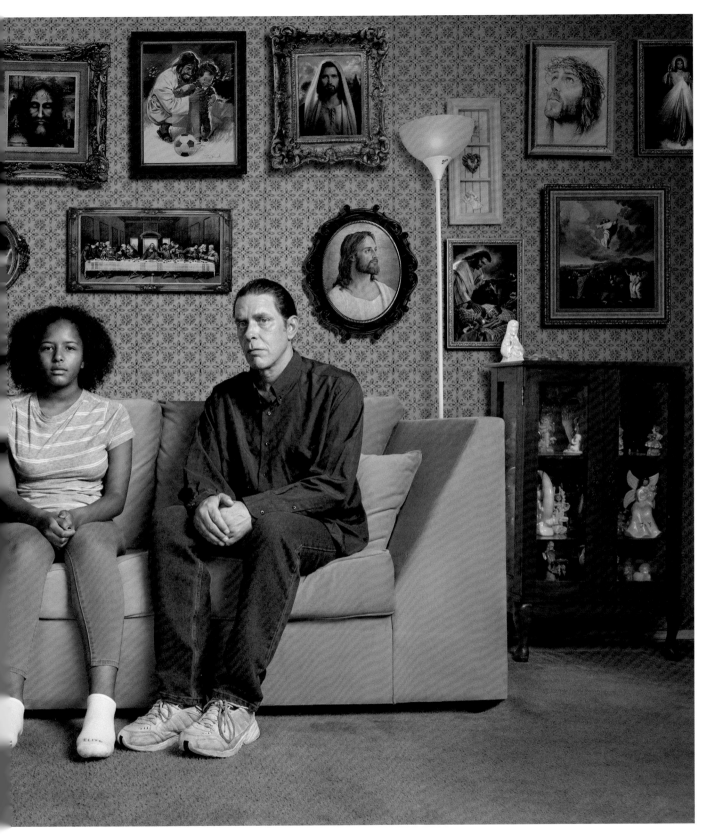

ABOVE GAZA: In the early 2000s, people living in the Gaza Strip became aware of Israeli military drones flying in the sky above their coastal enclave. Soon it became apparent that the drones were armed and could strike anywhere without warning. Ground control stations built inside camouflaged shipping containers (like this one) are used to pilot large unmanned aerial vehicles (UAVs). This hangar is used as a showroom by the company that produces UAVs and related systems for clients around the world, including the Israeli military.

DANIEL TEPPER AND VITTORIA MENTASTI
UNITED STATES

danieltepper.us / vittoriamentasti.com

VILLE KUMPULAINEN
FINLAND

villekumpulainen.com

OUT OF SIGHT: My unstable relationship with the past forces me into a state of deconstruction and rewriting old archival materials. Through my images, I grow roots deep into my hidden memories and my unconscious—illuminating what has been hidden away out of sight. My photographs fill the breaks between past and present.

SELF-PORTRAIT: Dhaka train station, Bangladesh. This shot was taken the day before the Islamic holiday of Eid. I saw the anxiety, tiredness, and frustration of this person and tried to capture the image at this specific moment in order to tell his story in my own way. This is something like a self-portrait.

MD ENAMUL KABIR
BANGLADESH

flickr.com/photos/enamul_kabir_rony

ELEMENTAL FORMS: LANDSCAPES: My practice is informed by an experimental approach to early photographic processes as well as my interest in the image as object. For example, this photograph is a wet plate collodion photogram made on black aluminum. Taken as a whole, the series is my contemplation on the transience of nature and on the boundaries between the self and the physical environment.

NADEZDA NIKOLOVA-KRATZER
UNITED STATES

nadezdanikolova.com

IT'S ALL IN THE EYES: A thousand pasts in the presence of a future, of what we've seen, and where we've been.

MARIANNE MARPLONDON
UNITED KINGDOM

marplondon.com

ROGER GRASAS
SPAIN

rogergrasas.com

MIN TURAB: Durma, Riyadh, Kingdom of Saudi Arabia.
In recent decades, the landscapes of the Persian Gulf
have undergone a dramatic mutation driven by increased
income from oil, globalization, and mass tourism. This
image holds up a mirror to the dyad of nature and
technology in a place where the old and new come
together while the lines between them blur completely.

GUOMAN LIAO
CANADA

guomanliao.com

TIME AND SPACE: Our fast-paced lives not only degrade the quality of our leisure, but also estrange our relationship to real-time social interactions. By composing my images in a humorous manner, these portraits reflect on the ways we react to our contemporary society.

LENGHI TENG
<u>THE NETHERLANDS</u>

lenghiteng.com

METAMORPHOSIS: A lot is expected from us in this society—increasingly, how we value ourselves and one another is predicated on performance. Sometimes we realize the truth: perfection doesn't exist. When we withdraw from the demanding world, we reflect on ourselves and discover that change is needed to achieve self-compassion.

MY STEALTHY FREEDOM: IRAN:
With the windows of my Tehran apartment covered with tinfoil, the camera's flash flash was not visible from outside; we were safe to create and let creativity flow. These Iranian women, forced to wear the hijab by the country's political (and religious) regime, find avenues for defiance. To make these portraits, each woman threw her brightly colored headscarf in the air. While it inescapably floated back to them, I captured their brave challenge to repressive Iranian laws.

MARINKA MASSÉUS
THE NETHERLANDS

marinkamasseus.com

GAMES OF PATRIOTS: In accordance with a decree from the government of the Russian Federation concerning "the patriotic education of citizens," the number of children's summer camps whose primary focus is on military training has risen. In addition to external, visible manifestations of patriotism, I try to explore the internal states of mind and emotions of these children, who are undergoing hard training at a young age.

MISHA PETROV
RUSSIAN FEDERATION

mishapetrov.com

INFINITE TENDERNESS: My intention is to empower others and create an accepting space for queer kids that grow up in small towns and rural areas. Through this work, I have documented the exploration of one's body, sexuality, and gender that comes along with growing up and identifying oneself. This is a visual representation of today's American youth.

PEYTON FULFORD
UNITED STATES

peytonfulford.com

I GOT SOMETHIN' TO SHOW YOU: Buffalo, New York is one of America's large cities, but it has the third-lowest median household income of any of these urban centers. My images were made in the tight-knit neighborhood of Old First Ward. There, I found a defiant and stalwart group of people standing together in the face of hard times.

SHANNON DAVIS
UNITED STATES

visual64.com

JURORS, BY COMPETITION

EMERGING TALENT AWARDS 2017

Sean O'Hagan: Critic and Writer, *The Guardian* and *The Observer*, London, United Kingdom

Emilia van Lynden: Artistic Director, Unseen, Amsterdam, The Netherlands

Chris Littlewood: Photography Director, Flowers Gallery, London, United Kingdom

Chris Pichler: Founder and Publisher, Nazraeli Press, California, United States

Muhammed Muheisen: Two-Time Pulitzer Prize-Winning Photojournalist, Amsterdam, The Netherlands

Debra Klomp Ching: Owner and Director, Klompching Gallery, Brooklyn, United States

Arianna Rinaldo: Artistic Director, Cortona On The Move, Cortona, Italy

Jim Casper: Editor-in-Chief, LensCulture, Amsterdam, The Netherlands

PORTRAIT AWARDS 2017

Susan White: Photography Director, *Vanity Fair Magazine*, New York, United States

Phillip Prodger: Head of Photographs, National Portrait Gallery, London, United Kingdom

Jennifer Pastore: Photography Director, *WSJ. The Wall Street Journal Magazine*, New York, United States

Whitney Johnson: Deputy Director of Photography, *National Geographic*, Washington, D.C., United States

Todd Hido: Artist, San Francisco Bay Area, United States

Fiona Rogers: Global Business Development Manager, Magnum Photos, London, United Kingdom

Genevieve Fussell: Senior Photo Editor, *The New Yorker*, New York, United States

Jim Casper: Editor-in-Chief, LensCulture, Amsterdam, The Netherlands

STREET PHOTOGRAPHY AWARDS 2017

Caroline Hunter: Picture Editor, *The Guardian Weekend Magazine*, London, United Kingdom

Olivier Laurent: Photography Editor, *The Washington Post*, Washington D.C., United States

Molly Roberts: Senior Photography Editor, *National Geographic Magazine*, Washington, D.C., United States

Sam Barzilay: Co-Founder, Photoville, New York City, United States

Jacob Aue Sobol: Photographer, Magnum Photos, Copenhagen, Denmark

Jim Casper: Editor-in-Chief, LensCulture, Amsterdam, The Netherlands

EXPOSURE AWARDS 2018

Stacey Baker: Photo Editor, *The New York Times Magazine*, New York, United States

Mazie Harris: Assistant Curator of the Department of Photographs, Getty Museum, Los Angeles, United States

Michael Mack: Publisher, MACK Books, London, United Kingdom

Elisa Medde: Managing Editor, *Foam Magazine*, Amsterdam, The Netherlands

Fiona Shields: Head of Photography, *The Guardian*, London, United Kingdom

Aida Muluneh: Founder/Managing Director, Addis Foto Fest, Addis Ababa, Ethiopia

Anna Walker Skillman: Owner/Director, Jackson Fine Art, Atlanta, United States

Jim Casper: Editor-in-Chief, LensCulture, Amsterdam, The Netherlands

LIST OF PHOTOGRAPHERS

MEMBERS OF THE LENSCULTURE TEAM

Laura Sackett
Kamran Mohsenin
Jim Casper
Millie Casper
Alexander Strecker
Coralie Kraft
Winifred Chiocchia
Alyssa Fujita Karoui
Elizabeth Kardon
Farid Bagishev
Jason Houston
Deb Pang-Davis
Ignace Blanco
Jhara Soriano
Lauren Jackson
Nina Tsarykovich
Aleks Dorohovich
Anastasia Ogienko
Dima Bezrucho
Kamyar Mohsenin
Nick Neumann

LensCulture is a global platform dedicated to discovering and sharing the best of contemporary photography. We are also actively engaged in helping photographers move forward in their careers both creatively and professionally.

Through our online magazine and social media channels, we reach a monthly audience of over 3 million. With this platform, we are able to expose the work of talented photographers to a worldwide audience. In addition, we sponsor several prestigious international awards every year, which have boosted the careers of hundreds of photographers around the world. An important component to these competitions is personal, written feedback for the entrants, which helps them improve their work and advance their creative vision.

Visit us online at lensculture.com to learn more and discover the best in contemporary photography, every day.

ISBN 978 90 5330 902 5

© 2018 All images by the respective photographers
© 2018 (Texts and compilation) LensCulture,
 Berkeley (CA), USA
 www.lensculture.com
© 2018 Schilt Publishing, Amsterdam
 www.schiltpublishing.com

Front cover photograph © Coco Amardeil
Back cover photograph © Fabien Fourcaud

Art direction & design
Heijdens Karwei, Amsterdam
www.heijdenskarwei.com

Proofreading
Kumar Jamdagni, The Netherlands
www.language-matters.nl

Print & Logistics Management
Komeso GmbH, Stuttgart
www.komeso.com

Printing
Offizin Scheufele, Stuttgart
www.scheufele.de

Distribution in North America
Ingram Publisher Services
One Ingram Blvd.
LaVergne, TN 37086
IPS: 866-400-5351
E-mail: ips@ingramcontent.com

Distribution in the Netherlands and Flanders
Centraal Boekhuis, Culemborg

Distribution in all other countries
Thames & Hudson Ltd
181a High Holborn
London WC1V 7QX
Phone: +44 (0)20 7845 5000
Fax: +44 (0)20 7845 5055
E-mail: sales@thameshudson.co.uk

Schilt Publishing & Gallery books, special editions and
prints are available online via www.schiltpublishing.com
Inquiries via sales@schiltpublishing.com